Renoir's Women

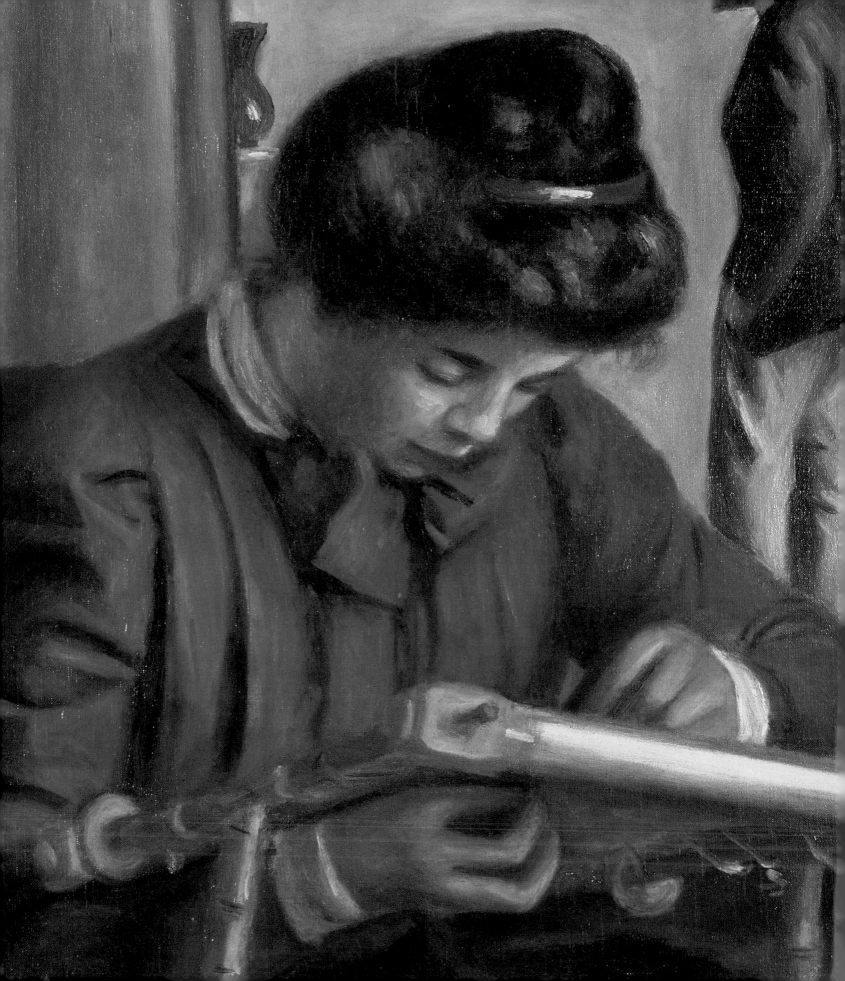

Renoir's Women

ANN DUMAS AND JOHN COLLINS

Columbus Museum of Art

IN ASSOCIATION WITH

MERRELL

LONDON · NEW YORK

First published 2005 by Merrell Publishers Limited

Head office
81 Southwark Street
London SE1 0HX

New York office
49 West 24th Street, 8th floor
New York, NY 10010

www.merrellpublishers.com

In association with

Columbus Museum of Art
480 East Broad Street
Columbus, OH 43215

www.columbusmuseum.org

Published on the occasion of the exhibition
Renoir's Women, curated by Ann Dumas for
Columbus Museum of Art and presented
September 23, 2005–January 8, 2006,
at Columbus Museum of Art

British Library Cataloging-in-Publication Data:
Dumas, Ann
Renoir's women
1.Renoir, Auguste, 1841–1919 – Exhibitions 2.Women
in art – Exhibitions
I.Title II.Collins, John, 1957– III.Columbus Museum
of Art
759.4

ISBN 1 85894 315 9
Produced by Merrell Publishers
Designed by Nicola Bailey
Copy-edited by Kirsty Seymour-Ure

Printed and bound in China

ANN DUMAS is an independent art historian and curator affiliated to the Royal Academy of Arts in London. Her field of interest is nineteenth- and early twentieth-century French painting. She has been a curator of major exhibitions for the Royal Academy of Arts, London, including *1900: Art at the Crossroads*, *Paris: Capital of the Arts*, and *Matisse: his Art and his Textiles*; and, for The Metropolitan Museum of Art, New York, *The Private Collection of Edgar Degas* and *Ambroise Vollard: Patron of the Avant-Garde*.

JOHN COLLINS is Assistant Curator of European Art, at the National Gallery of Canada. He is a Renoir specialist and has written numerous articles on the artist, as well as contributing to the major 1997 exhibition *Renoir's Portraits* in Ottawa, Chicago, and Fort Worth. He has made a number of appearances on Arts television programs, including the BBC series *Private Life of a Masterpiece*.

JACKET FRONT
Madame Henriot, c. 1876 (p. 34)

JACKET BACK
Christine Lerolle Embroidering, c. 1895–98 (p. 86)
The Green Jardinière, 1882 (p. 27)
Thérèse Berard, 1879 (p. 43)

PAGE 2
Christine Lerolle Embroidering, c. 1895–98 (p. 86)

All pictures are by Pierre-Auguste Renoir, unless otherwise stated

ACKNOWLEDGMENTS

Renoir's Women, the exhibition and the book, are possible because of the efforts of many people. Across time zones, an ocean, national boundaries, and languages, a remarkable group of people and institutions collaborated. We especially thank the following organizations and individuals, without whom *Renoir's Women* would not have been realized.

The owners of these marvelous works by Renoir, those in the exhibition, those in this book, and especially those appearing in both, merit our special thanks. Without their generosity and support, our walls and these pages would have been blank.

Authors and curators researching topics and assembling exhibitions and publications call upon many for assistance. We were fortunate to have been able to rely upon Götz Adriani, Graham Beal, Emily Braun, Guy Cogeval, Philip Conisbee, Anne Distel, Claudia Einecke, Marina Ferretti, Simonetta Fraquelli, Flemming Friborg, Gloria Groom, Ellen Lee, Katharine Lee Reid, Jean-Patrice Marandel, Larry Nichols, Maureen O'Brien, Michael Parke-Taylor, Robert McD. Parker, Richard Rand, Christopher Riopelle, Jean-Marie Rouart, Ann Sumner, and Kenneth Wayne. Jessie Turner cheerfully provided expert research assistance and helped facilitate transatlantic communications.

A production of this size and scope requires considerable financial support, and we were fortunate that a number of friends shared our vision and made *Renoir's Women* possible. Our corporate sponsors were generous with their support: Huntington Bank, Presenting Sponsor; The Columbus Dispatch, WBNS 10TV, dispatch.com, ThisWeek Community Newspapers, and Columbus Parent, Lead Sponsor; Cardinal Health, Major Sponsor; Limited Brands, Major Sponsor. Complementing our corporate sponsors were these wonderful donors: Rhoma Berlin, Lesley Blanchard, Jeri Block and Robert H. Schottenstein in memory of Maxine Block, Deborah Brooks, Ann Casto in honor of Nancy Casto Benson, Loann Crane, Paige Crane, Lisa Edwards, Barbara Fergus, Bebe Finn, Joyce Gertmenian, Franklin Foundation in memory of Freda Davidson Luethi, Ann S. Hoaglin, Linda Hondros, Marci Ingram, Nancy Jeffrey, Patty Jurgensen, Linda Kass, Charlotte Kessler, Mary Kidder, Monica Kridler, Cheryl Krueger, Mary K. Lazarus in honor of Babette L. Sirak, Floradelle Pfahl, Ann Pizzuti, Grant Morrow and Cordelia Robinson in honor of Shirle Westwater, Sharon Brunelle Rosholt, Ellen Ryan, Jody Scheiman, Susan Scherer, Thekla R. Shackelford, Barbara Siemer, Tina Skestos, Sally Ross Soter, Lee Szykowny, Barbara Trueman, Sara Wilcox, Sarah Ziegler, and an anonymous gift. For the publication of this book, we also gratefully acknowledge the Mrs. Richard M. Ross Publication Fund of the Columbus Museum of Art.

Merrell Publishers is blessed with a staff of wonderful people, and we thank Publisher, Hugh Merrell; Art Director, Nicola Bailey; Production Manager, Michelle Draycott; Production Controller, Sadie Butler; Managing Editor, Anthea Snow; Editor, Sam Wythe; Junior Editor, Helen Miles; and, most especially, U.S. Director, Joan Louise Brookbank.

Everyone at Columbus Museum of Art—the board of trustees, volunteers, and staff—contributed to *Renoir's Women*. We especially thank trustee Ann S. Hoaglin; Chief Curator, Catherine Evans; Associate Curator of European Art, Dominique H. Vasseur; Head of Exhibition Programs, John Owens; Director of Research and Planning, Louisa Bertch Green; Deputy Director of Operations, Rod Bouc; Director of Education, Carole Genshaft; Director of Marketing and Communications, Melissa Ferguson; Visitor Services Director, Pam Edwards; Exhibition Design and Production Manager, Greg Jones; Deputy Director for Institutional Advancement, Nancy Duncan Porter; Director of Membership and Annual Fund, Debbie Mehok; and Renoir Consultant, Jennifer McNally.

Renoir's Women would never have come about were it not for the generosity, knowledge, and passion of Howard and Babette Sirak. Although "Babs" passed away in September 2004, her spirit remains with us.

Nannette V. Maciejunes
Executive Director
Columbus Museum of Art

Ann Dumas
Guest Curator
London

FOREWORD

The Columbus Museum of Art is pleased and proud to present *Renoir's Women*, published to accompany the exhibition. While Pierre-Auguste Renoir has been the subject of numerous exhibitions, hundreds of books, and uncounted articles, this is the first time that scholars have focused exclusively on the artist's complex, sometimes contradictory, relationships with women. And because women played so great a role in Renoir's life, professional and personal, *Renoir's Women* is especially significant.

The Columbus Museum of Art has long had an intense interest in European Modernism. The magnificent collection of Ferdinand Howald established a sound collections foundation, which generations of curators have built upon with considerable success. In 1991, sixty years after Mr. Howald's donation, Howard and Babette Siraks' stunning collection, which includes three works by Renoir, came to the museum. These collections established the museum as a major repository of early European Modernism, and these works have been borrowed for exhibitions around the world. And from these collections, Columbus Museum of Art curators and guest curators have mounted exhibitions—most recently *Monet to Matisse: The Triumph of Impressionism and the Avant-Garde*—and produced publications.

Renoir's Women is the first of several exhibitions and books inspired by works from the museum's collection in a series focusing on various aspects of European Modernism that will provide, we trust, a wonderful journey along the road of this marvelous period of art.

We are especially pleased to be working with Ann Dumas, who is organizing these exhibitions and publications. We were fortunate to convince John Collins, a Renoir specialist, to contribute an excellent essay. Merrell Publishers has been a wonderful partner, and we thank Joan Louise Brookbank for her expertise, patience, and humor. For the Columbus Museum of Art, Chief Curator, Catherine Evans oversaw exhibition planning, with the assistance of Associate Curator of European Art, Dominique H. Vasseur. John Owens, with felicity and determination, undertook the arduous task of securing illustrations. Christopher S. Duckworth, chief editor, coordinated book publication with Merrell.

All of us associated with the Columbus Museum of Art, trustees and staff, firmly believe that art transforms and enriches people's lives. We are dedicated to creating great experiences with great art to reach as many people as possible. *Renoir's Women* is a manifestation of that belief and that commitment.

Nannette V. Maciejunes
Executive Director
Columbus Museum of Art

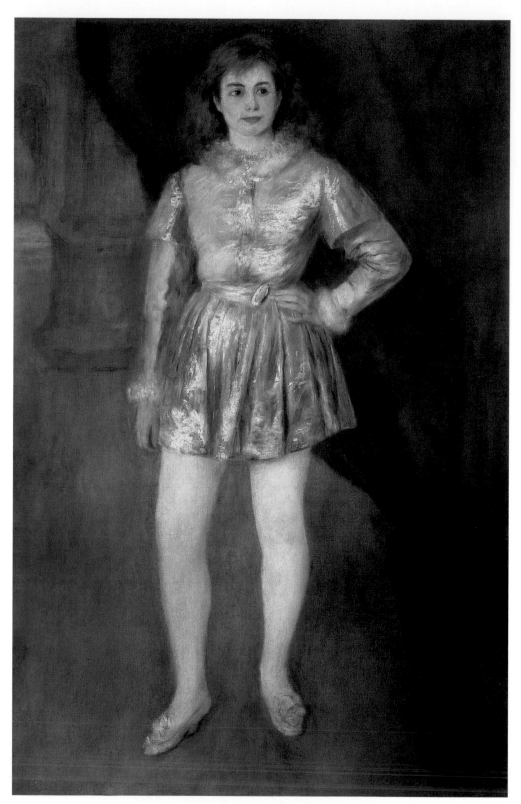

Fig. 1 *Madame Henriot en travesti (Madame Henriot in Costume)*, *c.* 1875–77
Oil on canvas, 63½ × 41¼ in. (161.3 × 104.8 cm)
Columbus Museum of Art, Museum Purchase, Howald Fund

RENOIR AND THE FEMININE IDEAL
An Introduction to Renoir's Women

ANN DUMAS

Renoir loved women. To the end of his life, it was by his paintings of women that he wanted to be judged. They provided him with his most potent source of inspiration and are at the center of the idyllic, harmonious worlds he constructed throughout his long career. Although in his female portraits Renoir often demonstrates a response to the looks and character of a particular sitter, in general he was interested in types rather than in individuals. His women represent different ideals of femininity, which shifted as his career evolved.

Taking as its starting point two different but equally engaging female portraits in the collection of the Columbus Museum of Art—*Madame Henriot en travesti* (fig. 1), a costume portrait of the Parisian actress dressed as a pageboy, and *Christine Lerolle Embroidering* (fig. 65), a genre portrait of the daughter of Renoir's friend the academic painter Henry Lerolle, painted about twenty years later—*Renoir's Women* sets out to explore Renoir's vision of women through the female types that emerge with the major themes that successively engaged him: the Parisiennes of his Impressionist period, portraits of society women and women in the home, little girls, maternity, costume pieces inspired by his trips to North Africa, and the great classical nudes of his final years.

The serene and sunny idylls that Renoir created in his art belie the artist's real-life character—a nervous, restless man with contradictory ideas about practically everything, including women. "I love women," he told his son Jean. "They doubt nothing. With them the world becomes something very simple. They give everything its correct value and well realize that their laundry is as important as the constitution of the German empire. Near them one feels reassured."[1] In general, Renoir conformed to the views of a typical conservative man of his time. He believed that a woman's place was in the home and that she should be practical and domestic. It was these qualities, combined with her dependability and simple country values, that Renoir admired in his wife, Aline, as he had in his mother. He was not a womanizer and was devoted to his family and domestic life. At home, however, he insisted that women be kept out of his own domain, the studio, and the women in his household referred to him as "the boss." Not surprisingly, perhaps, these attitudes went hand in hand with a deep dislike of educated and intellectual women. Feminist scholars have, in the last two decades, drawn attention to the fact that the Third Republic was a period that saw vigorous campaigning for women's rights, more education, equal opportunities, and better working conditions.[2] Renoir was well aware of these attitudes but was horrified by the idea of professional women, whom he thought of as "monsters," once claiming: "I can't see myself getting into bed with a lawyer. I like women best when they don't know how to read; and when they wipe their baby's behind themselves."[3] "When women were slaves, they were really mistresses. Now that they have begun to have rights, they are losing their importance," he observed on another occasion.[4] Renoir's friend Georges Rivière thought that Renoir did not really like women: "Though he gave women an appealing appearance in his paintings, and gave charm to those who had none, he generally took no pleasure in their conversation. With a few exceptions, he only liked women if they were susceptible to becoming his models."[5] Yet one must not forget that some of Renoir's most sympathetic portraits suggest a real liking for his sitter. He had a long-standing friendship with the Impressionist painter Berthe Morisot, an intelligent and talented woman for whom he had great respect. But whatever the complexities of Renoir's view of women in life, in his art they passively and unambiguously inhabit the artist's unclouded earthly paradise. In his quest for an ideal of womanhood, he made his models conform to a type. The "Renoir type" is plump

Fig. 2 *The Laundress,* 1877–79
Oil on canvas, 32¹⁄₁₆ × 22¼ in. (81.4 × 56.5 cm)
The Art Institute of Chicago, Charles H. and Mary F.S. Worcester Collection

and rounded with pearly pink skin, a snub nose, a full mouth, and wide eyes. She is usually blond. Clothed, she is pretty and vivacious. Nude, she has a vacant expression that reinforces the mood of timeless calm the artist is seeking to convey. Renoir once remarked that he deliberately engaged his models in banal conversation to induce a blank expression. But there is no doubt that, above all, Renoir delighted in women's physical appearance, both clothed and naked. He was highly responsive to the female nude, to radiant skin and luxuriant hair, and was captivated by chic young Parisiennes attired in the latest fashions.

The Parisienne

It is the pert, pretty Parisienne that we most readily associate with Renoir. He seems to have felt at ease with these *grisettes*—the laundresses, seamstresses, and milliners of Montmartre—girls from a similar working-class background to his own. Dressed in the latest fashions (fig. 3), dancing (fig. 67), in cafés (fig. 4), trying on hats (fig. 5), or caught up in the crowds along bustling elegant boulevards (fig. 8), they form the core of his work in the 1870s. During these years Renoir was a member of the avant-garde fringe group who, in 1874, became known as the Impressionists, when they organized the first of a series of exhibitions intended to offer an alternative to the immense and increasingly moribund state-sponsored Salon. Their mission, like that of the contemporary writers in the Naturalist movement, Emile Zola and Guy de Maupassant, was to portray modern life. As Edmond Renoir observed of his brother's work in 1879: "Apart from its artistic value, his œuvre has the particular charm of a faithful picture of modern life. What he painted, we see every day; it is our existence which he has registered in pages which will surely remain among the most lively and the most harmonious of the age."[6] It is significant that Renoir's three submissions to the first exhibition of the Impressionist group, held in the studio of the photographer Nadar in 1874, should all be portrayals of women: *Dancer* (1874; National Gallery of Art, Washington, D.C.), *The Parisienne* (fig. 3), and *The Theater Box* (fig. 23). *The Theater Box*, which shows a quintessentially modern Parisian subject, a fashionable young woman in a box at the theater, is a masterpiece of fluent and luminous painting, beautifully conveying the feel and texture of diaphanous lace, skin, and pearls. With

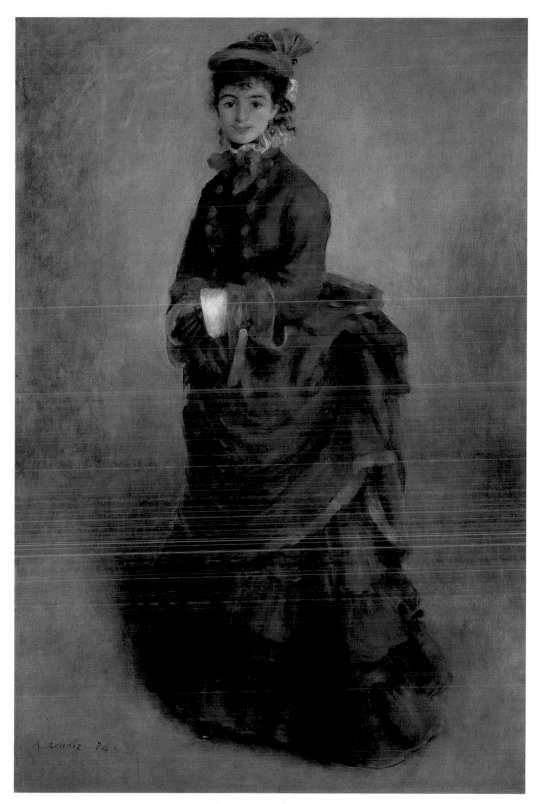

Fig. 3 *The Parisienne*, 1874
Oil on canvas, 63 × 41½ in. (160 × 106 cm)
National Museums and Galleries of Wales, Cardiff

Fig. 4 *At the Café, c.* 1877
Oil on canvas, 13¾ × 11 in. (35 × 28 cm)
Kröller-Müller Museum, Otterlo

Fig. 5 *At the Milliner's, c.* 1878
Oil on canvas, 12¾ × 9⅗ in. (32.4 × 24.5 cm)
Fogg Art Museum, Harvard University Art Museums, Cambridge MA

Fig. 6 *Young Girls (In the Street)*, *c.* 1877
Oil on canvas, 17⁵⁄₁₆ × 14⅛ in. (44 × 36.5 cm)

Ny Carlsberg Glyptotek, Copenhagen

Fig. 7 *La Place Clichy, c.* 1880
Oil on canvas, 25½ × 21¼ in. (65 × 54 cm)
Fitzwilliam Museum, University of Cambridge, Cambridge

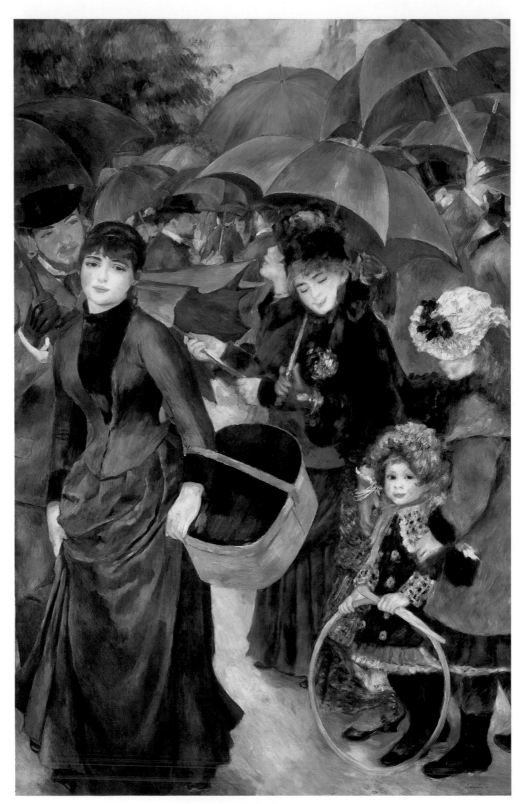

Fig. 8 *The Umbrellas, c.* 1881–85
Oil on canvas, 71 × 45½ in. (180 × 115 cm)

The National Gallery, London

the monumental *The Parisienne* (fig. 3), whose subject is an archetypal modish young woman of the day, Renoir probably took his cue from fashion plates in the contemporary journals that were so eagerly perused by chic Parisiennes (fig. 10). Although the model was the actress Mlle Henriette Henriot, the title *The Parisienne* indicates Renoir's intention to portray a contemporary type rather than an individual sitter.

Renoir had grown up in Paris, the son of a tailor and a dressmaker. The family had moved from Limoges, a town in central France renowned for porcelain manufacture, to Paris when Renoir was three. They set up home in what was, in effect, a slum district squeezed between the palaces of the Tuileries and the Louvre, where Renoir had easy access to the great masters of the past—Titian, Veronese, Watteau, and Boucher—who were to have such a lasting effect on his future development. Renoir was, at thirteen, apprenticed to a painter of porcelain in the rue des Fossés-du-Temple in the 9th arrondissement of Paris, on the edge of Montmartre. Here he painted plates and vases with images of Marie-Antoinette and details of compositions by Boucher and Watteau. The experience of painting on porcelain gave him a fluid technique that he never lost. In the evenings he studied drawing at a free school. To make ends meet, Renoir also had a stint painting murals in restaurants, before enrolling in 1861 at the informal painting school run by the Swiss history painter Charles Gleyre (1806–1874), at the same time attending drawing classes at the Ecole des Beaux-Arts, Paris's leading art school. Renoir's experience in Gleyre's studio proved crucial, for it was here that he met the talented Frédéric Bazille (who was tragically killed in the Franco-Prussian War in 1870), and two artists who would become leaders of the Impressionist group, Claude Monet and Alfred Sisley. At around this time Renoir also got to know two other artists who were to feature prominently in the development of modern French painting, Paul Cézanne and Camille Pissarro. Moreover, Gleyre, although himself known for his academic, historical subjects, differed from his more rigid peers in that he encouraged his pupils' individuality and urged them to paint out of doors and mix their colors on the spot, thus fostering an awareness of the effects of nature and a spontaneous way of working, both of which were fundamental to the Impressionist enterprise. In 1864, Renoir made his début at the annual official Salon, to which he submitted several works over the next few years, enjoying a particular success in 1868 with his large-scale portrait of his mistress Lise Tréhot in a white dress with a parasol (fig. 11).

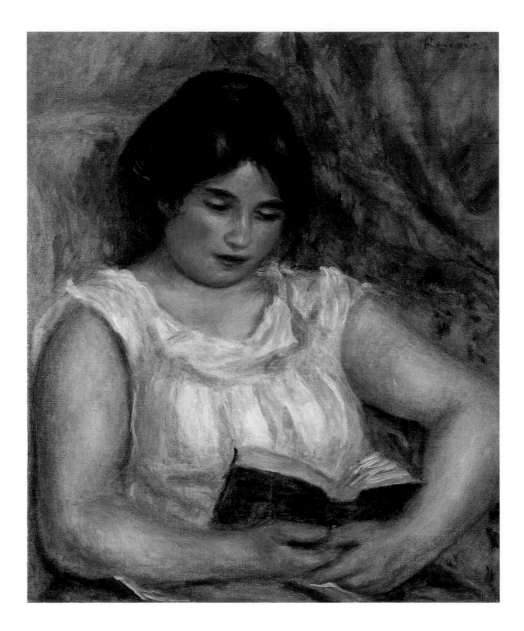

Fig. 9 *Gabrielle Reading*, 1906
Oil on canvas, 21⅝ × 18⅜ in. (55 × 46.5 cm)
Staatliche Kunsthalle, Karlsruhe

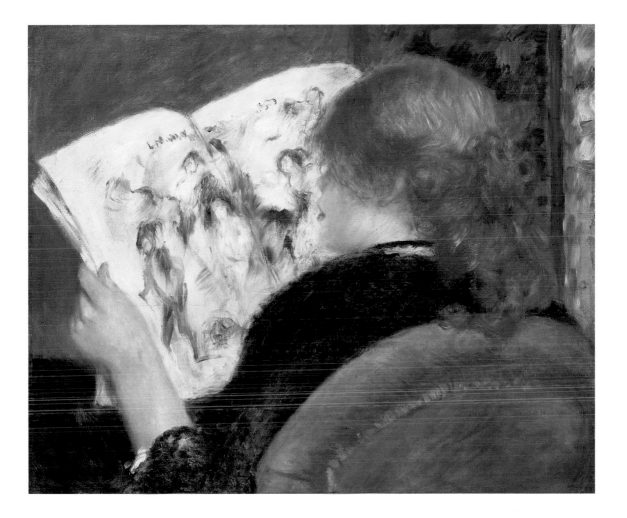

Fig. 10 *Young Woman Reading an Illustrated Journal, c.* 1880–81
Oil on canvas, 18 × 22 in. (46 × 56 cm)

Museum of Art, Rhode Island School of Design, Providence, Museum Appropriation

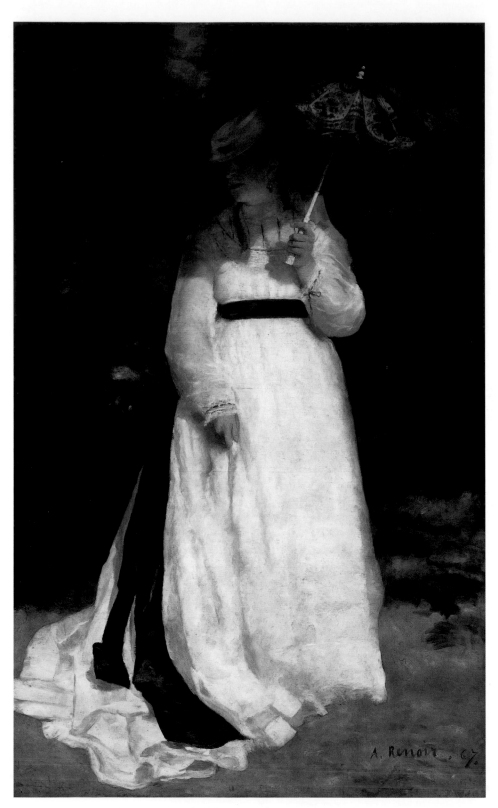

Fig. 11 *Lise (Woman with a Parasol)*, 1867
Oil on canvas, 71½ × 44½ in. (184 × 115 cm)
Museum Folkwang, Essen

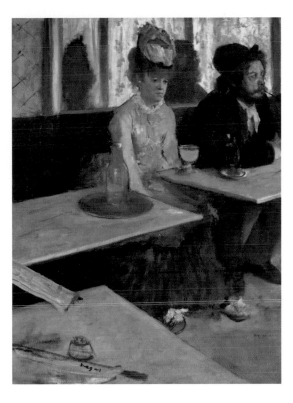

During the 1870s, Renoir was living a bohemian life in Montmartre, the district in the north of Paris with its windmills, gardens, cafés, and cabarets. His great masterpiece of these years, *Dance at the Moulin de la Galette* (fig. 67), for which a number of his friends posed, encapsulates the determinedly sunlit idyll he would sustain in his painting for the rest of his life. The theme of popular entertainment, of young women dancing, is pursued in a pair of large-scale paintings, *Dance in the Country* (fig. 13) and *Dance in the City* (fig. 14), which demonstrate Renoir's appreciation of the city girl in her white satin gown and long gloves, for which the model was the future artist Suzanne Valadon, and the rosy-cheeked country girl in her bonnet and spotted dress, alias Aline Charigot, Renoir's future wife. Other paintings of these years capture young women in the fashionable modern cafés, such as *At the Café* (fig. 4), a delightfully informal study that shows Renoir's love of the small format. Here, Renoir's optimistic approach offers a marked contrast with that of contemporary artists and writers in the Realist camp. Renoir once complained that Zola always saw the dark side of things, while Maupassant commented that Renoir always looked on the bright side.[7] When Edgar Degas chose to paint a café subject, he painted *At the*

Fig. 12 Edgar Degas (1834–1917), *At the Café (Absinthe)*, 1875–76
Oil on canvas, 36¼ × 26¾ in. (92 × 68 cm)
Musée d'Orsay, Paris

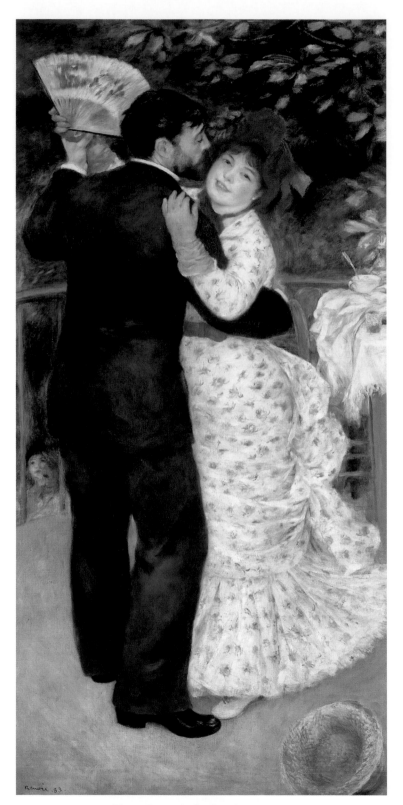

Fig. 13 *Dance in the Country*, 1882–83
Oil on canvas, 71 × 35½ in. (180 × 90 cm)
Musée d'Orsay, Paris

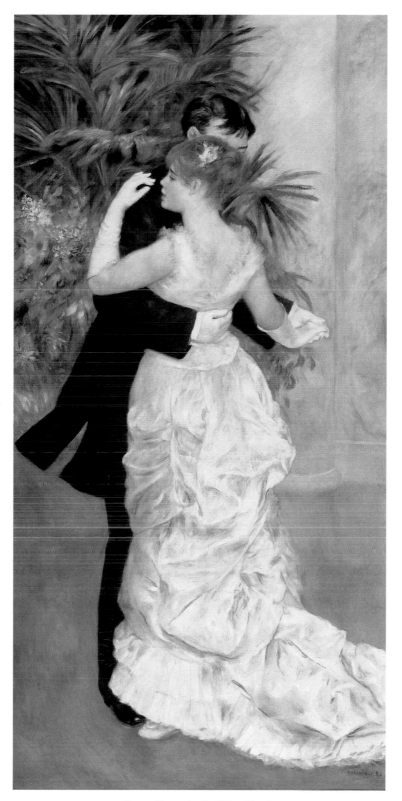

Fig. 14 *Dance in the City*, 1882–83
Oil on canvas, 71 × 35½ in. (180 × 90 cm)
Musée d'Orsay, Paris

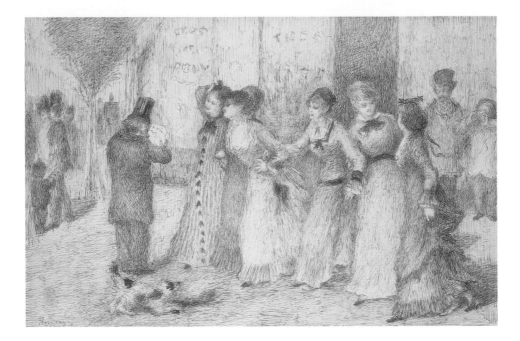

Café (Absinthe) (fig. 12), constructed like one of Renoir's modern-life tableaux using friends as models, in this case the actress Ellen André and the engraver Marcellin Desboutin obligingly playing the roles assigned them. But, unlike Renoir's happy café scene that celebrates the pleasures of urban life, Degas's melancholy subject is the corrosive effects of the addictive drink absinthe on two broken-down café *habitués*.

Especially revealing in this context are Renoir's illustrations for Zola's dark, modern-life tale of the decline and fall of a laundress, Gervaise, in *L'Assommoir*, published in 1877 (fig. 15). The discomfort Renoir felt with this doom-laden material meant that most of his illustrations are slight and out of keeping with the tone of the book, except, as Douglas Druick has pointed out, for the striking scene in which Gervaise's daughter, Nana, heroine of one of Zola's future novels, and her friends flaunt their teenage charms on the boulevard. With these raucous, flirtatious Parisiennes, out for a night on the town, Renoir is in his element, and the scene inspired, in this pen-and-ink drawing, one of his most accomplished multifigure compositions.[8]

While much of Renoir's essentially Parisian brand of Impressionism focuses on outdoor activity, another category of works, which includes *The Green Jardinière* (fig. 16), *The Piano Lesson* (fig. 17), *Woman at the Piano* (fig. 18), and *Seamstress at a Window* (fig. 20), depicts fashionable women engaged in indoor pursuits. In *The Green Jardinière* an elegant model, the light falling softly over her creamy skin and filmy white

Fig. 15 *Workers' Daughters on the Boulevard*
(Illustration for Emile Zola's *L'Assommoir*), 1877–78
Pen and brown ink, over black chalk, on ivory laid paper, 10½ × 15¾ in. (27.5 × 39.9 cm)
The Art Institute of Chicago, The Regenstein Collection

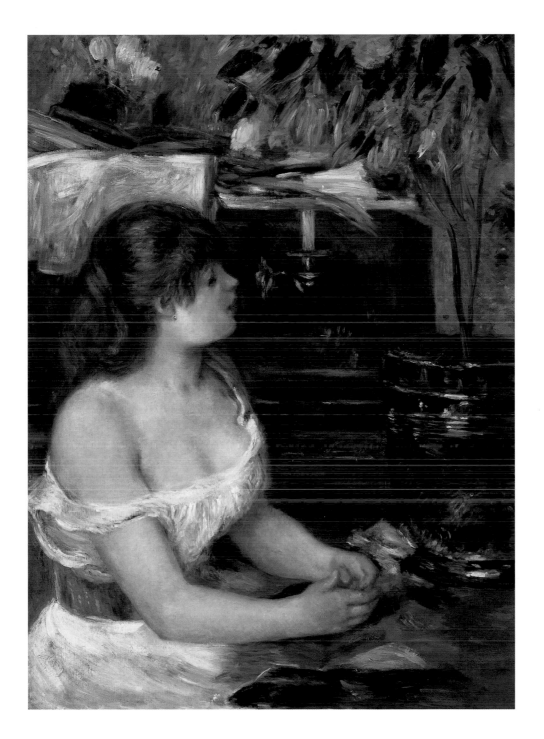

Fig. 16 *The Green Jardinière*, 1882
Oil on canvas, 36½ × 26¾ in. (92.7 × 67.9 cm)
Toledo Museum of Art, Purchased with funds from the Edward Drummond Libbey Endowment,
Gift of Edward Drummond Libbey

27

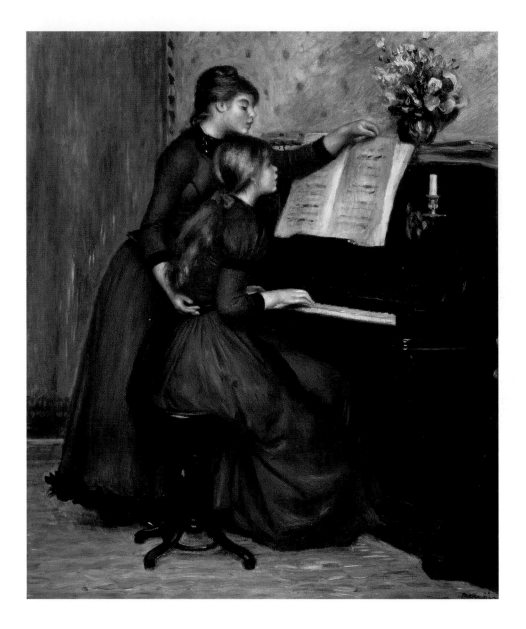

Fig. 17 *The Piano Lesson, c.* 1889
Oil on canvas, 22 × 18 in. (56 × 46 cm)
Joslyn Art Museum, Omaha, Museum Purchase

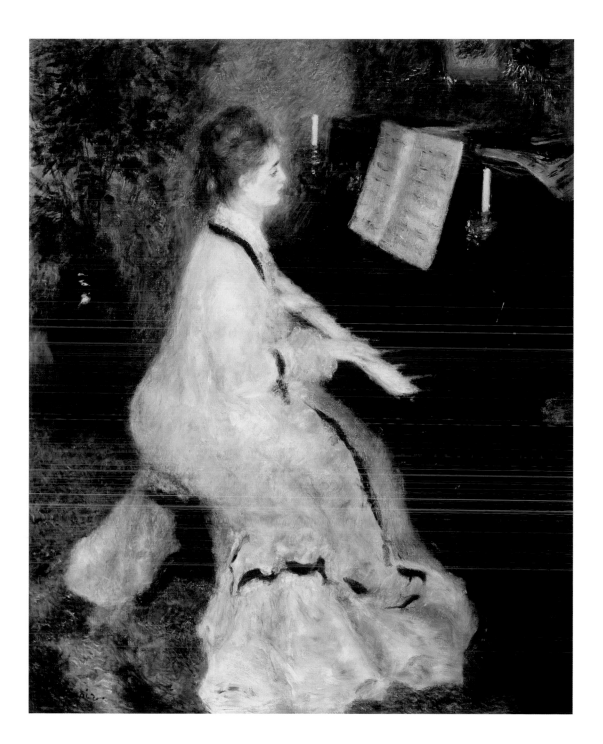

Fig. 18 *Woman at the Piano*, 1875–76
Oil on canvas, 36¾ × 29¼ in. (93.2 × 74.2 cm)
The Art Institute of Chicago, Mr. and Mrs. Martin A. Ryerson Collection

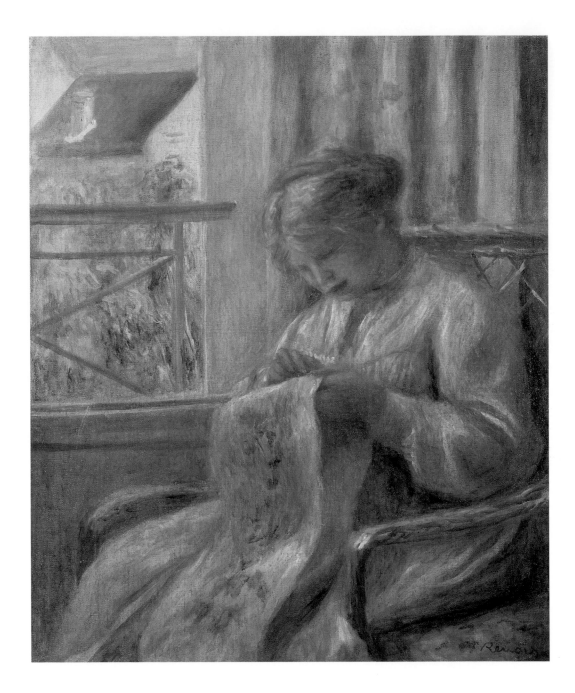

Fig. 19 *Portrait of a Girl Sewing,* 1900
Oil on canvas, 21¼ × 17¾ in. (54 × 45.1 cm)
Saint Louis Art Museum

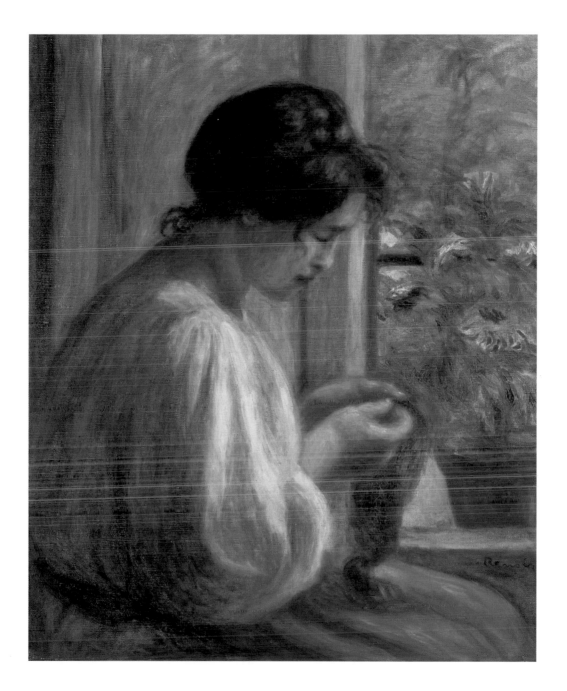

Fig. 20 *Seamstress at a Window, c.* 1908–10
Oil on canvas, 25½ × 21½ in. (64.8 × 54.6 cm)
New Orleans Museum of Art, Gift of Mr. Charles C. Henderson in memory of Margaret Henderson

dress, is seated in a well-appointed interior adorned with a piano and a luxuriant plant in a jardinière. Although the instrument is closed, one imagines that the sitter is an accomplished performer. Girls playing the piano were a popular subject at the time and one of Renoir's favorite themes. *The Piano Lesson* is, in effect, the first version of a composition that he was to explore in five oil paintings and a pastel for his major commission from the French State in 1892—to paint a picture to be purchased by the Musée du Luxembourg, the museum devoted to paintings by leading living artists. The two models, with their rounded figures, snub noses, rosy complexions, and golden hair, epitomize Renoir's Parisian type. The red dresses establish a warm chromatic scheme that suffuses the painting as a whole, creating a mood of joyful harmony that evokes similar images by the eighteenth-century French artists that Renoir so admired.

Together with piano playing, women reading and sewing are genre subjects rooted in both the French eighteenth-century and the Dutch seventeenth-century traditions, but which the Impressionists reinvented for their own time. Renoir is known to have had a profound love of the work of Vermeer, *The Lacemaker* (fig. 72) being a special favorite, as well as the works of Chardin, Fragonard, and Boucher, all of whom painted women absorbed in these quiet, domestic pursuits. In *Portrait of a Girl Sewing* (fig. 19) and *Seamstress at a Window* (fig. 20) the young women who sew, bathed in the warm light from a window, inevitably recall the meditative stillness of Vermeer. *Christine Lerolle Embroidering* (fig. 65) merges this familiar genre theme with portraiture.

Portraits

Renoir shows the daughter of his great friend and patron, the painter Henry Lerolle, quietly absorbed in the essentially feminine activity of embroidering. Although Christine's head is bent over her work, her features are not obscured. Unlike the genre paintings for which models posed, Renoir is at pains here to capture a genuine likeness of his gentle and attractive sitter, and to convey a sense of her cultivated milieu, with her connoisseur father discussing with a friend paintings from his distinguished collection of modern art. A more animated Christine appears with her sister Yvonne in another of Renoir's genre-portraits of the same year, *Yvonne and Christine Lerolle at*

Fig. 21 *Portrait of Marie-Zélie Laporte, c.* 1864
Oil on canvas, 22 × 18⅛ in. (55.8 × 46.1 cm)
Musée municipal de l'Evêché, Limoges

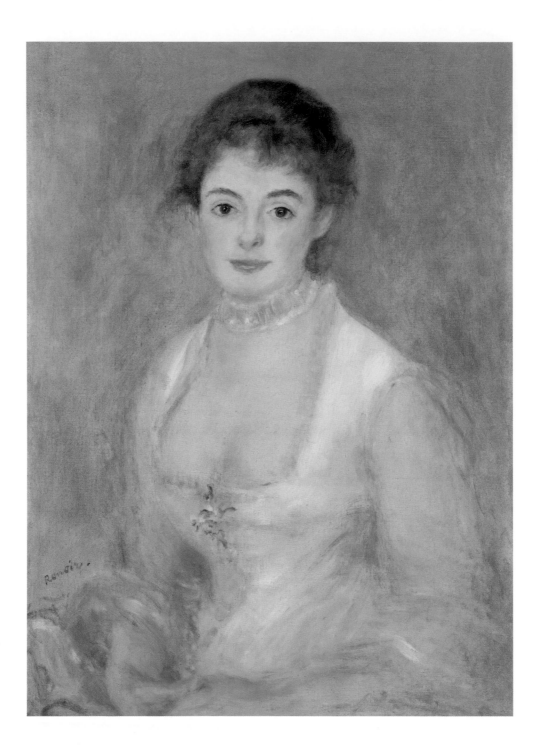

Fig. 22 *Madame Henriot, c.* 1876
Oil on canvas, 26 × 19⅝ in. (66 × 50 cm)
National Gallery of Art, Washington, D.C., Gift of the Adele R. Levy Fund, Inc.

the Piano (fig. 70), in which he returns to this familiar theme, showing the girls at home with paintings by Degas on the wall behind them.

Portraiture had been central to Renoir's œuvre in the first two decades of his career, and the majority of his portraits are of women. One of his earliest portraits, that of Marie-Zélie Laporte, the sister of the artist Emile Laporte, with whom Renoir became friends in the late 1850s when they were students together in Gleyre's studio, is remarkably fresh and direct (fig. 21). It demonstrates Renoir's mastery of subtle color at this early stage of his career, together with his gift for suggesting light and form through nuances of light tones, the *peinture claire*, which the painters of his generation learned from Camille Corot. Renoir's portraits of the 1860s were mostly of family and friends. By the 1870s, however, when he was at the forefront of the Impressionist group, his social milieu broadened to include the bohemian world of Montmartre with its artists, actresses, musicians, and writers, several of whom posed for the modern life tableaux that Renoir set up, most notably *Dance at the Moulin de la Galette* (fig. 67), *The Theater Box* (fig. 23), and *The Luncheon of the Boating Party* (fig. 39). Renoir's favorite model during this period was the young vaudeville actress Henriette Henriot. As Colin Bailey has observed, Henriette is remembered less for her accomplishments than for personal tragedy, when her illegitimate twenty-one-year-old daughter, Jane, a débutante at the Comédie Française, was killed when the theater caught fire in 1900.[9] She is the subject of at least eleven of Renoir's paintings between 1874 and 1876. She posed as the fashionably dressed *Parisienne* (fig. 3), appears in a typically modern life Parisian subject, on stage in a boy's theatrical costume in silvery satin, in the Columbus Museum of Art's *Madame Henriot en travesti* (fig. 1), and is also the subject of a beautiful formal portrait of great delicacy (fig. 22). Contemporary photographs reveal that Henriette was no beauty, and Renoir undoubtedly enhances her looks in this, one of his most tender portraits. Henriette's clearly delineated yet delicate face emerges from the diaphanous gauzy whites of her dress, painted with a sureness and lightness of touch that reminds us of Renoir's early beginnings as a painter of porcelain and, of course, of his love of the Rococo masters Watteau and Boucher.

In the mid-1870s, Renoir's social circle expanded. A significant meeting of these years was with Victor Chocquet (1821–1891), a minor customs official with a passion for painting and an unerring instinct for acquiring works by the greatest contemporary

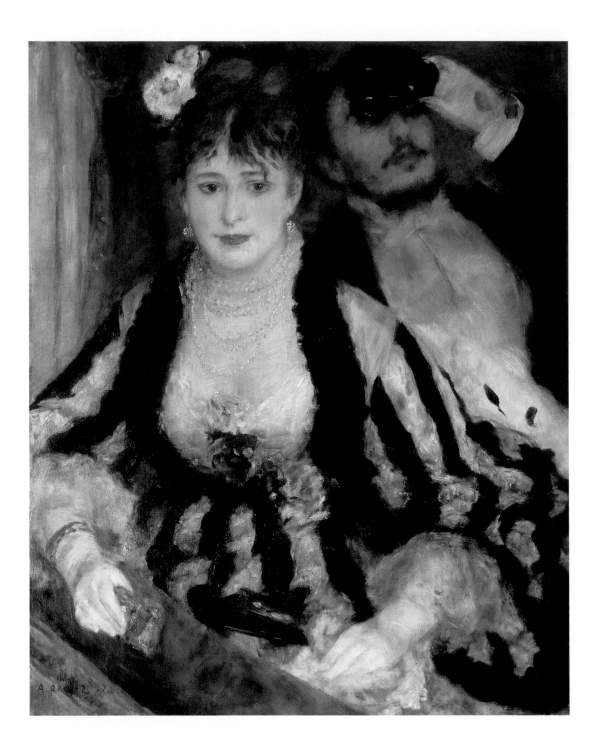

Fig. 23 *The Theater Box*, 1874
Oil on canvas, 31½ × 25 in. (80 × 63 cm)
Courtauld Institute Gallery, London, The Samuel Courtauld Trust

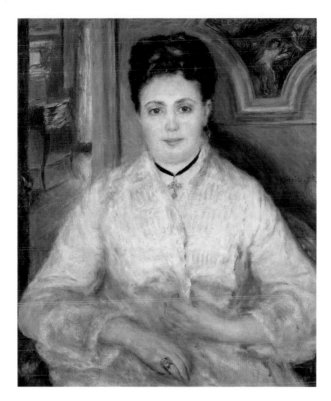

painters, despite his relatively modest means (although it is true that Impressionist paintings were inexpensive at the time). Chocquet filled his apartment on the rue de Rivoli opposite the Tuileries Gardens with paintings by Eugène Delacroix, Edouard Manet, Cézanne, Pissarro, and others. He would become one of Renoir's major supporters. How Renoir met Chocquet is not clear, but in 1875 he was asked to paint a portrait of the collector's wife, Augustine-Marie-Caroline (fig. 24). Renoir produced a sympathetic and intimate portrait, but one that perhaps lacks the warmth of those where he had a closer bond with the sitter, such as Henriette Henriot. Renoir shows works from Chocquet's collection: Delacroix's sketch for *Numa and Egeria* (Musée du Louvre) on the wall behind the sitter and, in the room to the left, a Louis XVI table and other gilt-framed paintings that evoke the collection.

Of greater import for Renoir's fortunes was his meeting in the mid-1870s with Georges Charpentier, publisher of the influential journal *La Vie moderne* and of the works of leading contemporary writers of the Naturalist school, including Zola and Maupassant. Charpentier's wife, Marguerite, was a celebrated literary hostess renowned for her soirées, where the intellectual and literary élite would mingle with

Fig. 24 *Madame Victor Chocquet*, 1875
Oil on canvas, 29½ × 23⅝ in. (75 × 60 cm)
Staatsgalerie, Stuttgart

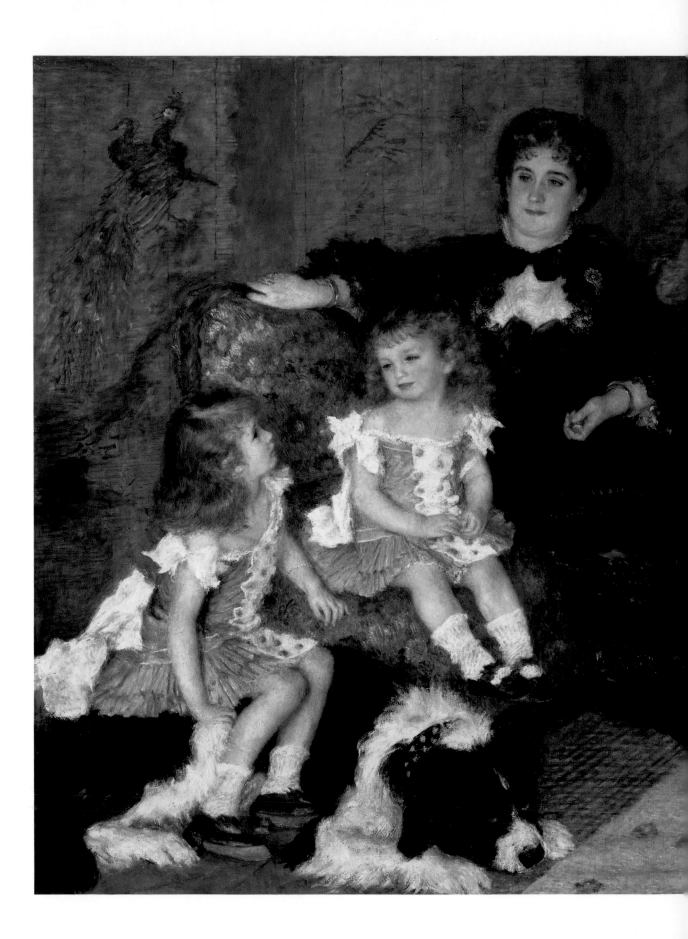

Fig. 25 *Madame Georges Charpentier and Her Children*, 1878
Oil on canvas, 60½ × 74⅞ in. (153.7 × 190.2 cm)
The Metropolitan Museum of Art, New York, Catharine Lorillard Wolfe Collection

statesmen and the beaumonde. The many portrait commissions that Renoir gained from these contacts were virtually his sole livelihood between 1876 and 1880; after that, the dealer Paul Durand-Ruel, famous for his association with the Impressionists, began to buy his work on a regular basis. Madame Charpentier was a sort of bourgeois Marie-Antoinette of the Third Republic (she would appear as Marie-Antoinette at costume balls) and Renoir became, in effect, the Charpentiers' court painter, as he himself ironically acknowledged when he signed a letter to her "painter in ordinary." Renoir set the seal on his association with the Charpentiers with his portrait *Madame Georges Charpentier and Her Children* (fig. 25). An astonishingly confident portrait, painted in a loose, bravura technique, it recalls the grand manner of portraits by Titian and Van Dyck. Marguerite Charpentier is seated in the elegant salon of her house in the rue de Grenelle, which is furnished in the fashionable Japanese taste with a screen and bamboo furniture. She is accompanied by her daughter Georgette, seated on the Newfoundland dog Porthos, and her son Paul, who is dressed as a girl, as was the fashion for small boys at the time. The composition is dominated by the sumptuous sweep of Madame Charpentier's black gown with its froth of white lace at the neck and hem, which is amusingly echoed in the recumbent black-and-white Porthos. Probably owing to the Charpentiers' influence, the portrait was prominently hung at the Salon and thus led to further portrait commissions for Renoir.

Children

Renoir was captivated by children—"their mouths utter only the words which animals would utter if they could talk,"[10] he once observed—seeking to convey in his paintings of them the notion of unaffected naturalness and the spontaneous response to what they saw with which he himself so strongly identified. As his son Jean explained in his biography of his father, "Renoir was always discovering and rediscovering the world at every instant of his existence, with every breath of fresh air he drew. … It is because of this eager child-like curiosity that Renoir was so fond of children."[11]

One of Renoir's first portraits of a small girl, *Mademoiselle Romaine Lacaux* (fig. 26), remains among his most acute and accomplished studies of children. Romaine

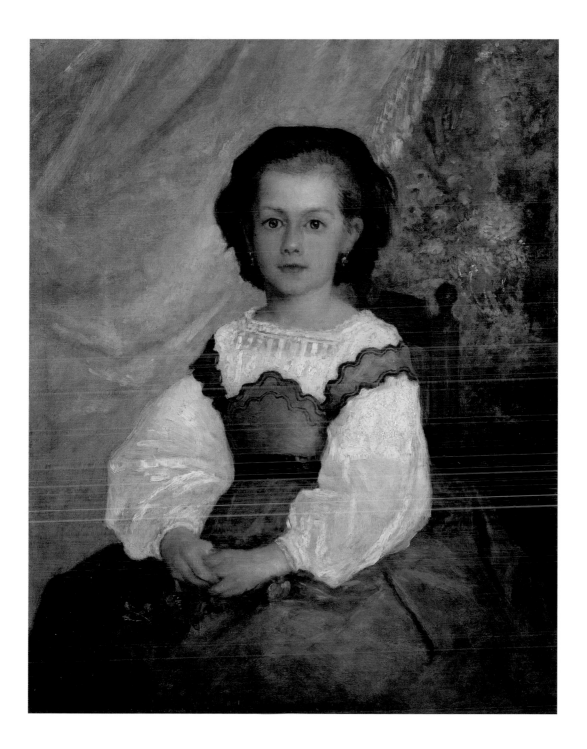

Fig. 26 *Mademoiselle Romaine Lacaux*, 1864
Oil on canvas, 32 × 25⅝ in. (81 × 65 cm)
The Cleveland Museum of Art, Gift of the Hanna Fund

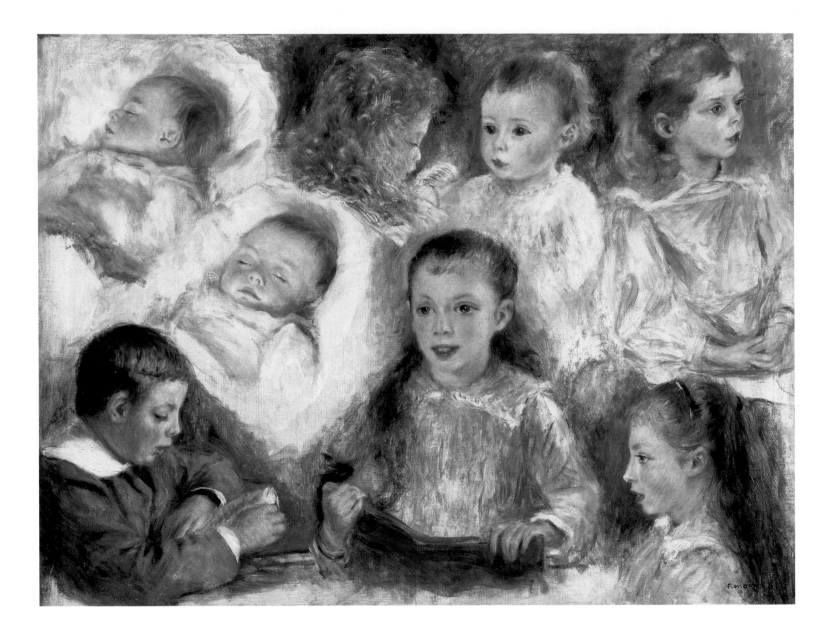

Fig. 27 *Studies of the Children of Paul Berard*, 1881
Oil on canvas, 24½ × 32½ in. (62.6 × 82 cm)
Sterling and Francine Clark Art Institute, Williamstown MA

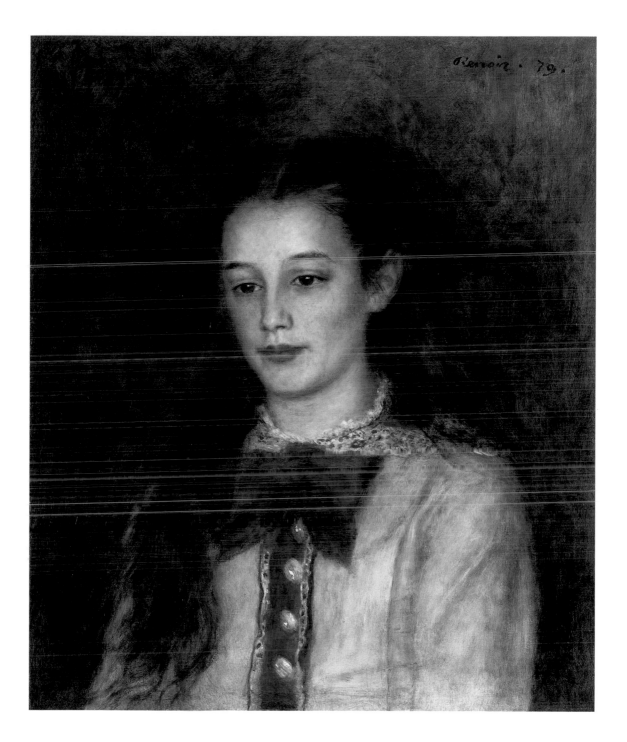

Fig. 28 *Thérèse Berard*, 1879
Oil on canvas, 22 × 18½ in. (56 × 47 cm)

Sterling and Francine Clark Art Institute, Williamstown MA

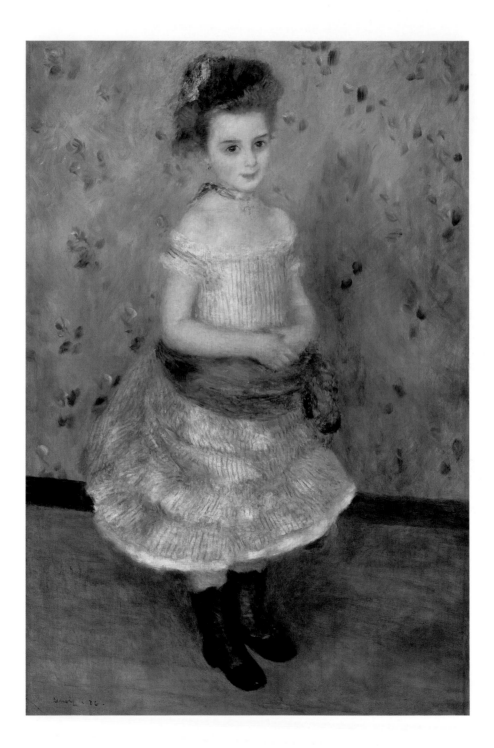

Fig. 29 *Jeanne Durand-Ruel,* 1876
Oil on canvas, 44 × 29½ in. (113 × 74 cm)
The Barnes Foundation, Merion PA

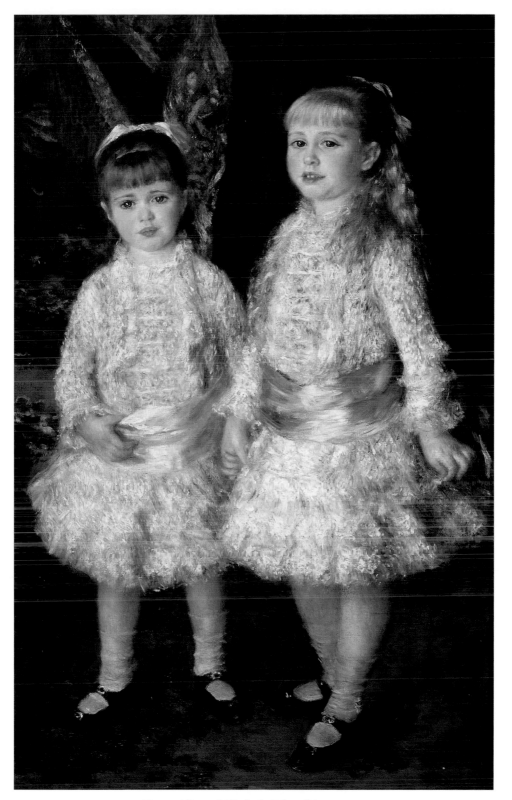

Fig. 30 *Alice and Elisabeth Cahen d'Anvers*, 1881
Oil on canvas, 47 × 29 in. (120 × 75 cm)
Museu de Arte de São Paulo

Louise Lacaux, who was nine when Renoir painted her, was the daughter of a manufacturer of earthenware goods, and it was perhaps through contacts he made as a porcelain painter that Renoir obtained this commission.[12] Renoir has adopted the conventions of formal portraiture for his portrayal of this alert little girl posed in front of a sweep of drapery. Inevitably, the youthful subject's costume and her dignified composure bring to mind Velázquez's seventeenth-century portraits of the Spanish infanta. Indeed, the portrait demonstrates Renoir absorbing the lessons of a number of artistic traditions—Velázquez again, in the bravura handling of paint, the linear precision of Ingres, and Corot's distinctive soft, creamy white and gray palette heightened with small, vivid accents of red and blue, which was so influential in the mid-nineteenth century.

Through the Charpentiers, Renoir met with the diplomat and banker Paul Berard, who became a friend and patron. Renoir was a frequent guest at Berard's country estate, the Château de Wargemont near Dieppe in Normandy. One of Renoir's most appealing studies of children is the portrait heads of all of the four Berard children seen from different angles on a single canvas, a study that has the delightful informality of a snapshot in a family album (fig. 27). The sensitive, if slightly distant, portrait of Berard's niece, Thérèse, her warm-toned skin and chestnut hair glowing

Fig. 31 *The Hat Pin*, 1897
Lithograph on paper, image 23 × 19¼ in. (58.4 × 48.9 cm)
The Minneapolis Institute of Arts, Gift of Bruce B. Dayton

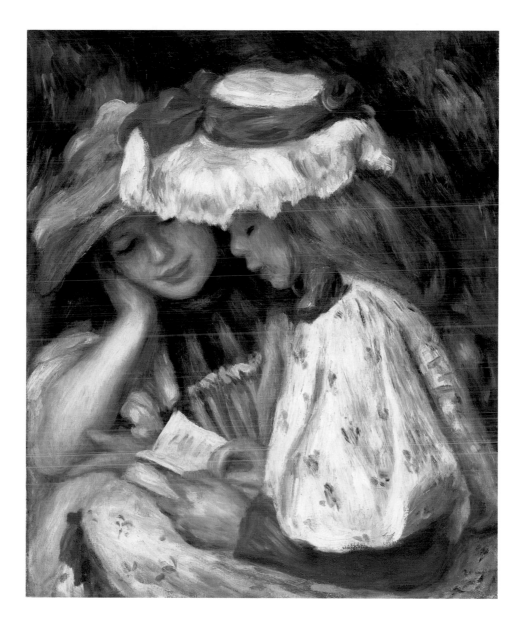

Fig. 32 *Two Girls Reading*, 1890–91
Oil on canvas, 22 × 18⅝ in. (55.9 × 47.2 cm)
Los Angeles County Museum of Art, The Armand Hammer Collection

Fig. 33 *Little Girl with a Hat*, 1894
Oil on canvas, 16¼ × 13 in. (41.2 × 33 cm)
Indianapolis Museum of Art, Presented to the Art Association by James E. Roberts

Fig. 34 *Young Girl with a Hat, c.* 1890
Oil on canvas, 16�5⁄16 × 12½ in. (41.5 × 32.5 cm)
The Montreal Museum of Fine Arts

against a reddish ground, shows the artist's sympathetic response to this rather reserved-looking girl (fig. 28).

Often Renoir's portraits of the children of his wealthy patrons express a more immediate affection and warmth than do his portraits of adults. A case in point is the ravishing double portrait of the little Cahen d'Anvers girls, Alice and Elisabeth, the daughters of a fabulously wealthy banker and his beautiful Italian wife (fig. 30). Standing holding hands in a sumptuously decorated room, the girls are dressed in their identical best party frocks with matching pink and blue ribbons, sashes and socks. Renoir's great achievement here is to preserve, despite the formality of setting and dress, the little girls' freshness and their particularly childish mixture of excitement and shyness. In the hands of a lesser artist, such a subject could so easily have slipped into the saccharine sentimentality that Renoir so successfully avoids.

Fig. 35 *The Gypsy Girl*, 1879
Pastel on prepared canvas, 23 × 14⅛ in. (58.4 × 33.9 cm)
Columbus Museum of Art, Gift of Howard D. and Babette L. Sirak, the Donors to the
Campaign for Excellence, and the Derby Fund

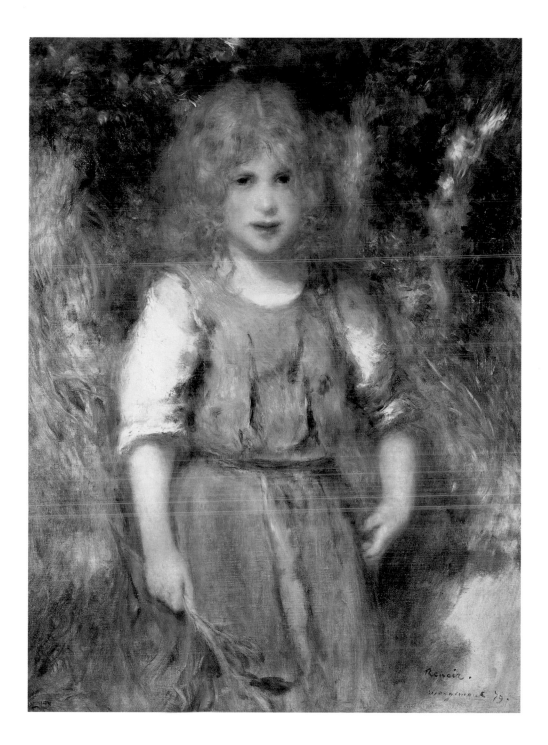

Fig. 36 *The Gypsy Girl*, 1879
Oil on canvas, 29 × 21½ in. (73.5 × 54.5 cm)

Herbert Black Collection, Canada

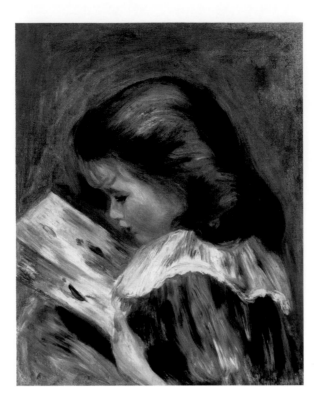

Renoir's depictions of young girls were not confined to commissioned portraits. The color lithograph *The Hat Pin* (fig. 31), for which the models were Julie Manet (the daughter of Berthe Morisot, who had recently died) and her cousin Paule Gobillard, is one of a number of appealing studies of girls in bucolic settings in which Renoir delights in their fresh complexions and pretty hats (figs. 32, 33, and 34). During his visit to Wargemont in the summer of 1879, Renoir painted not only portraits of the Berard family but also some local figures in their natural surroundings, including *The Gypsy Girl* in the Columbus Museum of Art (fig. 35) and the Herbert Black Collection (fig. 36). Picturesque gypsies were a popular theme in French Salon painting at the time and sought after by collectors. Here, the extremely loose handling of paint and the warm palette of yellows, pinks, and russet reds that enhance the girl's pale complexion and red hair create an image of great physical immediacy. Moreover, the child's gaze, disheveled appearance, and torn clothes suggest a hint of the erotic. In contrast to his commissioned portraits, which required the artist to convey the particularities of an individual's appearance, Renoir's interest here is in a rustic type and a certain genre of slightly sentimental child subject.

Fig. 37 *The Picture Book, c.* 1895
Oil on canvas, 15½ × 12½ in. (39 × 32 cm)
Collection of The Dixon Gallery and Gardens, Memphis, Museum Purchase

Maternity

Renoir's circumstances changed again when, in around 1880, he met a Montmartre seamstress, Aline Charigot, who had recently come to Paris from her native Essoyes in Champagne. Renoir first depicted her as one of the young models in his scenes of modern life—she is the pretty girl holding a dog at the lower left of *The Luncheon of the Boating Party* (fig. 39) and the model for *Dance in the Country* (fig. 11)—but after the birth of their first child, Pierre, in 1885, he came to associate her with her roots. In his undeniably affectionate portrait painted in the summer of 1885, after Pierre's birth (fig. 38), she is depicted as a warm-hearted, unaffected, red-cheeked country girl. He eventually married Aline in 1890. With Pierre's birth, Renoir embarked on a more settled family life. The portrait of Aline and the series of *Motherhood* paintings that he began in 1885 mark a shift in his work away from the Parisian modern-life subject toward more timeless themes.

Motherhood for Renoir represented an ideal expression of femininity. Pierre's birth inspired a whole group of works—two sanguine drawings, a number of informal

Fig. 38 *Portrait of Aline Charigot, later Madame Renoir*, 1885
Oil on canvas, 25¾ × 21¼ in. (65.4 × 54 cm)
Philadelphia Museum of Art, W.P. Wilstach Collection

Fig. 39 *The Luncheon of the Boating Party*, 1880–81
Oil on canvas, 51¼ × 69⅛ in. (130 × 173 cm)
The Phillips Collection, Washington, D.C.

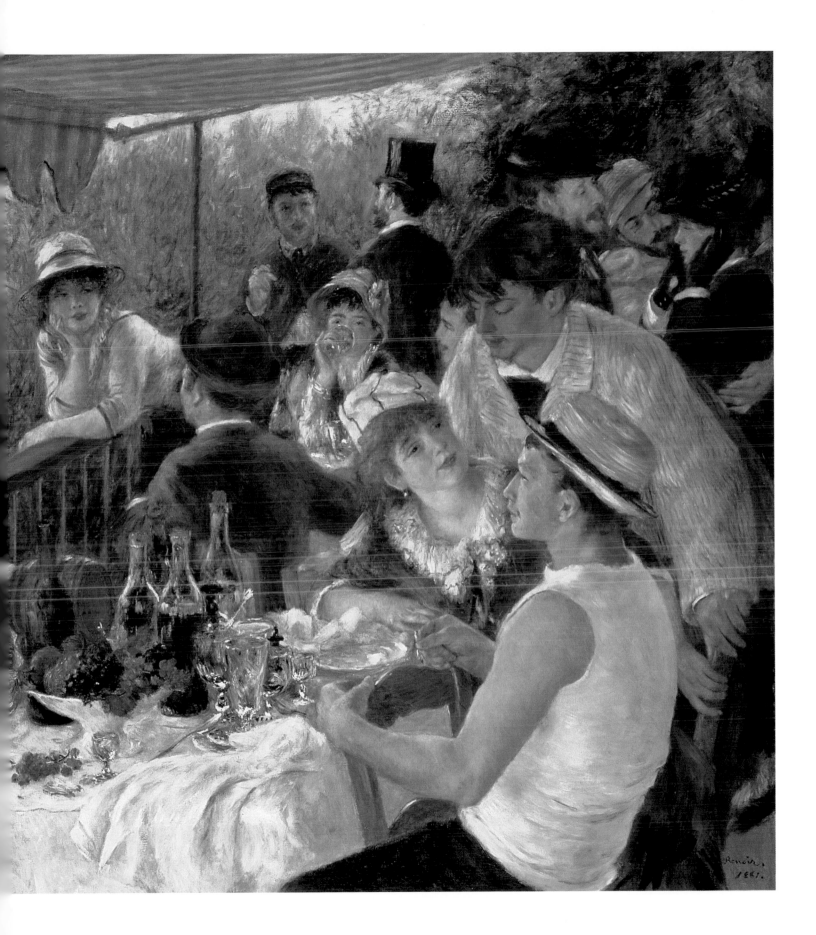

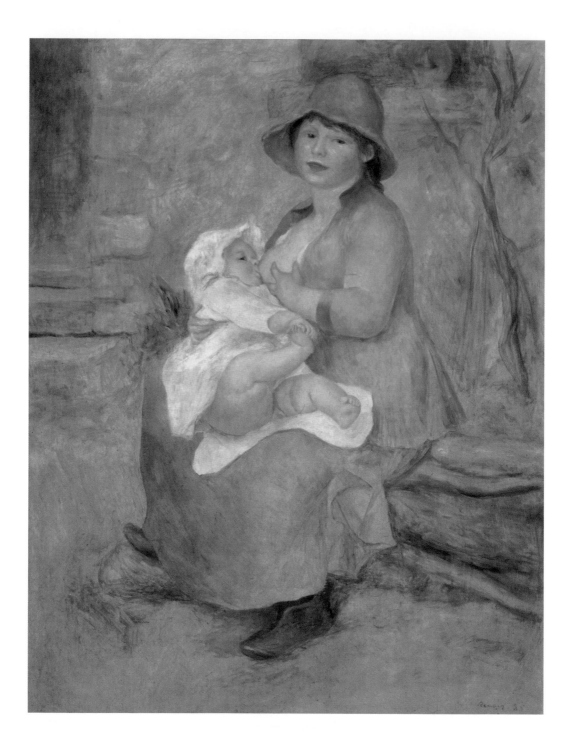

Fig. 40 *Motherhood*, 1885
Oil on canvas, 35¾ × 28½ in. (91 × 72 cm)
Musée d'Orsay, Paris

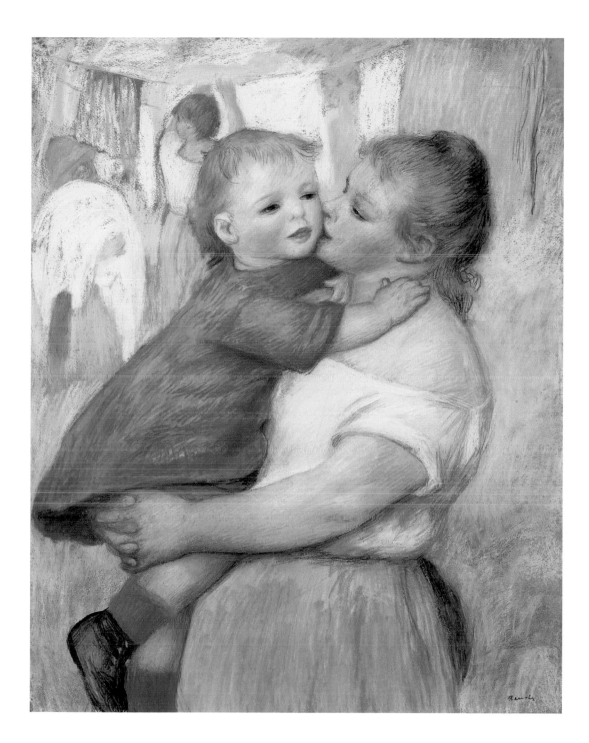

Fig. 41 *Mother and Child (Aline and Pierre/Washerwoman and Baby)*, *c.* 1886
Pastel, 32 × 25¾ in. (79 × 63.5 cm)
The Cleveland Museum of Art, jointly owned by the Museum and an anonymous collector

Fig. 42 *The Lesson, c.* 1906
Oil on canvas, 25½ × 33½ in. (65 × 85 cm)

Private collection, London, via Galerie Daniel Malingue, Paris

drawings, and three oil paintings entitled *Motherhood* (including fig. 40) showing Aline suckling the baby—and the later and vividly immediate large pastel of mother and child, executed when Pierre was about two (fig. 41). In contrast to the striking individuality of Renoir's portrait of Aline, her features in *Motherhood* are more generalized, with the result that she becomes a type, a representative icon of rustic motherhood. The gesture of the baby grasping his foot has the immediacy of direct observation, but at the same time, Renoir imbues his subject with a timeless monumentality. The pyramid structure of the composition as well as the harmonious, curving rhythms of the figures derive from Raphael's Madonna and Child paintings, which had come to represent the image of motherhood for Renoir during his trip to Italy in the autumn of 1881. In particular, he admired Raphael's celebrated *Madonna della Sedia* in the Pitti Palace, Florence, which he described as "the most free, the most solid, the most marvellously simple and alive painting that one could imagine; the arms and legs have real flesh, and what a touching expression of maternal tenderness!"[13] The enduring meaning for Renoir of this image of Aline and her child is endorsed by the fact that he painted another version of it after her death in 1915 and chose it for the memorial sculpture made by his assistant Richard Guino in 1918 (figs. 44, 45).

Some of Renoir's most engaging images of women and children depict his second son, Jean, born in 1894, attended not by his mother but by his nurse, Gabrielle Renard. A distant cousin of Aline, Gabrielle had joined the family a month before Jean's birth and would stay with them for the next nineteen years. In particular, Renoir explored the theme of woman and child in a series of touching and intimate domestic scenes showing Gabrielle and Jean, executed during the autumn and winter of 1895 to 1896, which he revisited some sixteen years later in a lithograph (fig. 43). Much of the warmth of these paintings springs from their close focus and the luminous technique that Renoir was now using. He seems to have relished the intimacy and freedom offered him by such non-commissioned subjects: "One must be personally involved in what one does. At the moment I am painting Jean pouting. It's no easy thing, but it's such a lovely subject, and I assure you I am working for myself and myself alone," he wrote to a friend.[14]

The birth of Renoir's third and last child, Claude ("Coco"), in August 1901, provided a new source of inspiration (fig. 42). The portrait of the baby Claude in the

arms of his nursemaid Renée Jolivet, considered by Jean Renoir to be the most memorable of the nursemaids and models after Gabrielle,[15] is one of Renoir's most austere compositions (fig. 73). In comparison with the warm and rich palette of many works of this date, *Claude and Renée* is based on a play of whites and creams in the child's dress and bonnet and in Renée's blouse and apron, enriched by the warmer tones of pink and yellow in the rosy complexions and golden hair, which also enliven the neutral background. Isolated against this empty space, the figures assume an almost sculptural presence. It is no coincidence that around this time Renoir commented to Ambroise Vollard on the eternal stillness of ancient sculpture.[16] Again, we see Renoir in his later work consistently looking to the old masters. The lineage of the Madonna and Child theme clearly lies behind this striking image and, as John House has pointed out, the technique of using thin washes of paint and suggesting form through color and tone owes much to Renoir's admiration for Rubens, as he explained to Vollard: "One day, in the Louvre, I noticed that Rubens had achieved more sense of values with a simple scumble (*frottis*) than I had been able to with all my thick layers of paint."[17]

Fig. 43 *Mother and Child, c.* 1912
Lithograph, 19½ × 18⅞ in. (49.5 × 47.9 cm)
Memorial Art Gallery of the University of Rochester, New York, Marion Stratton Gould Fund

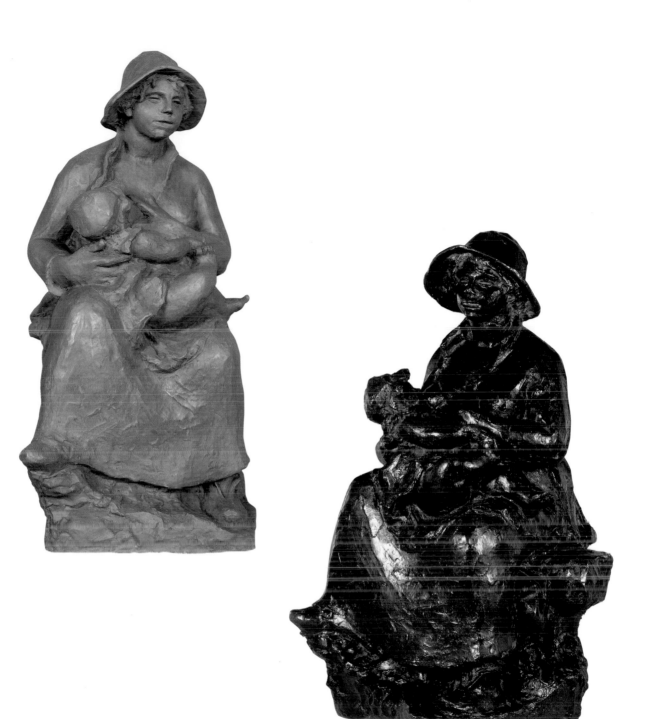

Fig. 44 *Maternity: Madame Renoir and Son*, *c.* 1916
Terracotta, 20⅛ × 9¾ × 12¾ in. (51.1 × 24.8 × 32.4 cm)
National Gallery of Art, Washington, D.C., Collection of Mr. and Mrs. Paul Mellon

Fig. 45 *Mother and Child*, 1916
Bronze, height 21³⁄₁₆ in. (53.8 cm)
The Baltimore Museum of Art, The Cone Collection, formed by
Dr. Claribel Cone and Miss Etta Cone of Baltimore MD

Orientalism

By 1881, Renoir's financial position was assured, when the Impressionist dealer Paul Durand-Ruel began to sell his work. This newfound prosperity meant that Renoir could afford to travel, and in 1881 he made his first two foreign trips, to North Africa and to Italy. In choosing North Africa he was following in the footsteps of one of his artistic heroes, the French Romantic painter Delacroix, and anticipating Henri Matisse's later quest for the exotic. But long before this trip Renoir, responding to collectors' taste for the Oriental, had produced some magnificent costume pieces, including *Madame Clémentine Valensin Stora in Algerian Dress* of 1870 (fig. 46), the splendid portrait of a North African Jewish woman, the wife of an Algerian antiques dealer who had a shop in Paris specializing in North African goods; and the sumptuous *Odalisque* (fig. 47), also of 1870, which was clearly indebted to Delacroix and for which Renoir's mistress Lise Tréhot was the model.[18] Renoir paid direct homage to Delacroix in 1875 when he made an exact copy of Delacroix's *The Jewish Wedding in Morocco* (1837–41), which was in the Louvre.[19]

But it was not until his visits to Algeria in the springs of 1881 and 1882 that Renoir was able to respond directly to the picturesque life and vivid colors of North Africa. The result was a series of fluently brushed and vibrant landscapes and about seventeen figure paintings, nearly all of Algerian women, mostly painted during his second trip in 1882, in which he is clearly fascinated by their colorful costume. Like Matisse, Renoir loved rich textiles and costumes, once commenting: "I like beautiful materials, rich brocade, diamonds flashing in the light, but I would have a horror of wearing such things myself. I am grateful to those who do wear them, provided they allow me to paint them. On the other hand, I would just as soon paint glass trinkets and cotton goods costing two sous a yard. It is the artist who makes the model."[20] Among the most engaging of Renoir's Algerian subjects is the enchanting *Mademoiselle Fleury in Algerian Costume* (fig. 49), remarkable for its vivid color and virtuoso passages of paint. Possibly this was a commissioned portrait of the daughter of a French colonial family stationed in Algeria,[21] or perhaps this colorful little girl just caught the artist's eye.

Renoir never returned to Algeria. Nevertheless, memories of the exotic lingered long in his mind to resurface many years later in some opulent compositions produced

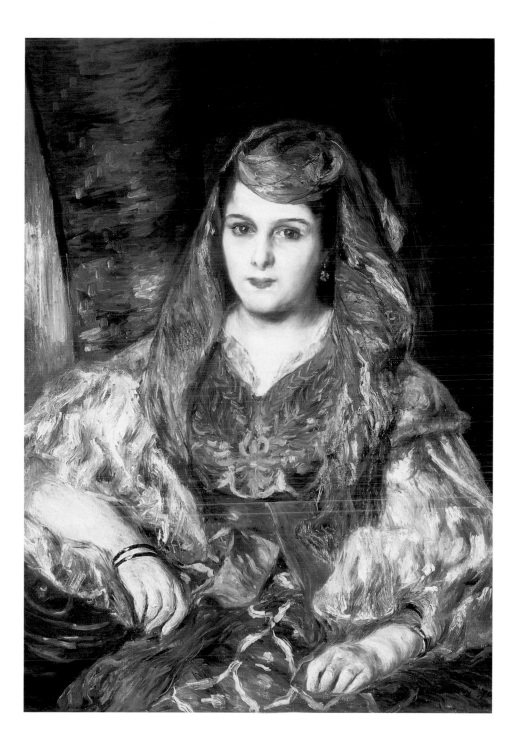

Fig. 46 *Madame Clémentine Valensin Stora in Algerian Dress*, 1870
Oil on canvas, 33¼ × 23½ in. (84.5 × 59.6 cm)
Fine Arts Museums of San Francisco, Gift of Mr. and Mrs. Prentis Cobb Hale in honor of Thomas Carr Howe, Jr.

Fig. 47 *Odalisque*, 1870
Oil on canvas, 27¼ × 48¼ in. (69.2 × 122.6 cm)
National Gallery of Art, Washington, D.C., Chester Dale Collection

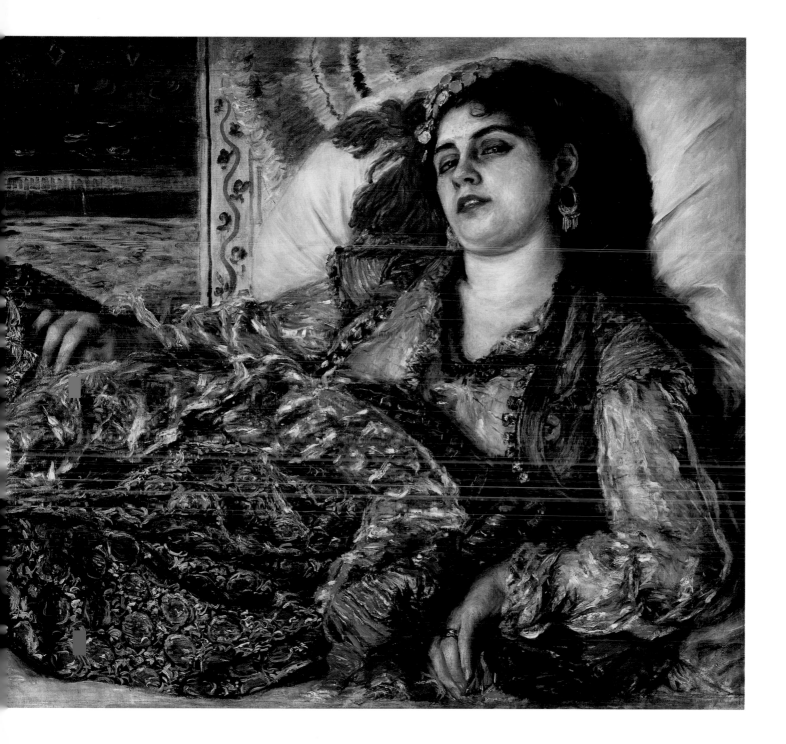

during the last phase of his career. Two grand panels, *Dancing Girl with Tambourine* and *Dancing Girl with Castanets* (figs. 50, 51), executed in 1909 for the Parisian businessman Maurice Gangnat, are in tune with the popularity of Oriental themes in the early years of the twentieth century, which were taken up by many Salon artists as well as by so avant-garde a painter as Matisse. These resplendent dancing girls are based on a number of sources, including both Classical Greek art and Spanish art, though the costumes seem North African. Two other works painted right at the end of Renoir's career pursue the Orientalist theme, but in the case of all his late work, forms dissolve in a generalized, dreamlike evocation far removed from the direct observation that characterizes the Algerian works produced thirty years before. *The Concert* and *Woman with a Mandolin* (figs. 52, 53) were painted probably in the last year of his life. Both are a glowing testament to the artist's lifelong affirmation of sensual beauty and a recapitulation of a number of his themes: girls with flowers, girls in exotic costume, and music-making. *The Concert*, in particular, can be seen as a final affirmation of Renoir's determination to see "*la vie en rose*." Flooded with a warm, rosy light, all the elements of the painting are woven together into a harmonious whole of rich color, texture, and light.

Fig. 48 *Reclining Odalisque*, 1919
Oil on canvas, 13⅜ × 22¹⁄₁₆ in. (34 × 56 cm)
Ny Carlsberg Glyptotek, Copenhagen

Fig. 49 *Mademoiselle Fleury in Algerian Costume*, 1882
Oil on canvas, 49¾ × 30¾ in. (126.5 × 78.2 cm)
Francine and Sterling Clark Art Institute, Williamstown MA

Fig. 50 *Dancing Girl with Tambourine*, 1909
Oil on canvas, 61 × 25½ in. (155 × 64.8 cm)

The National Gallery, London

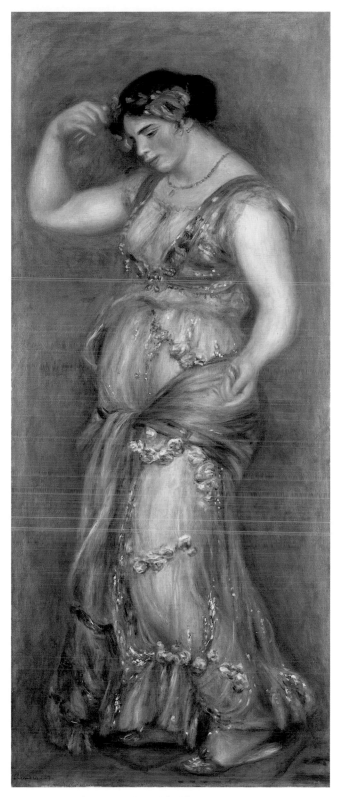

Fig. 51 *Dancing Girl with Castanets*, 1909
Oil on canvas, 61 × 25½ in. (155 × 64.8 cm)
The National Gallery, London

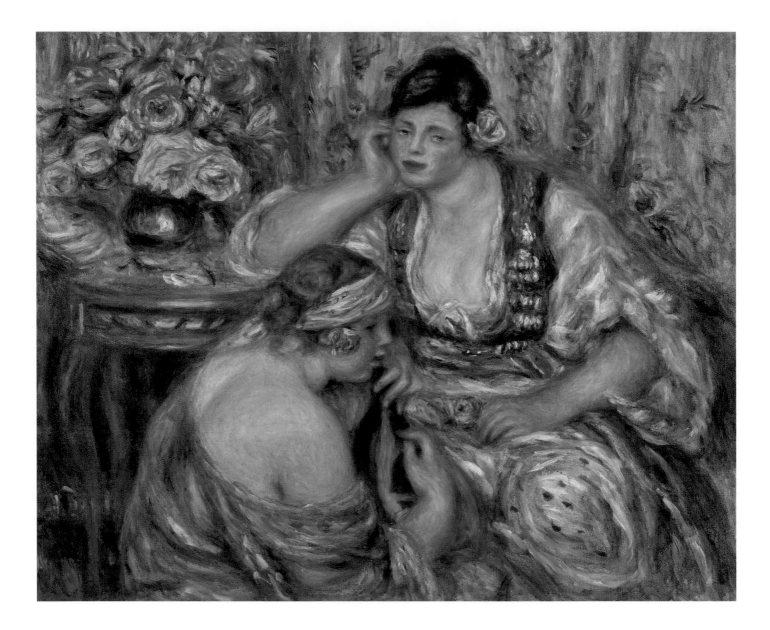

Fig. 52 *The Concert*, 1918–19
Oil on canvas, 29¾ × 36½ in. (75.6 × 92.7 cm)
Art Gallery of Ontario, Toronto, Gift of Rubens Wells Leonard Estate

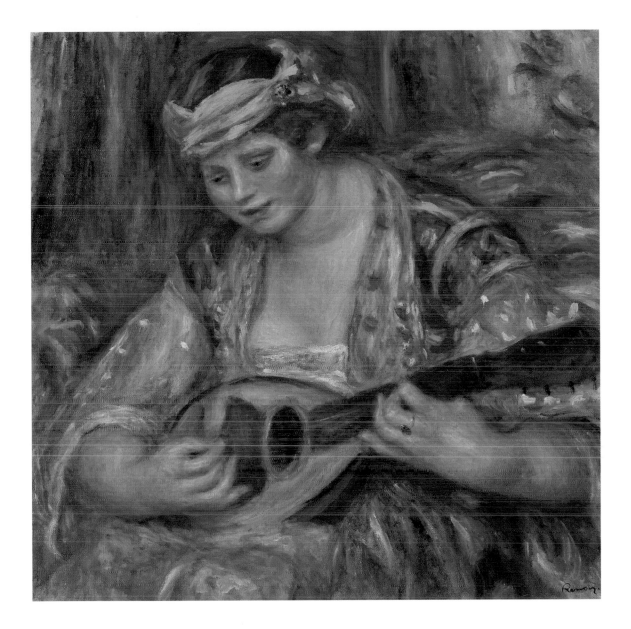

Fig. 53 *Woman with a Mandolin*, 1919
Oil on canvas, 22 × 22 in. (56 × 56 cm)

Collection of Rita K. Hillman

Bathers

For Renoir, the nude embodied his ideal of the feminine and the idea of woman as a natural being. His female nudes, more than any other subject, demonstrate Renoir's intense physical response to his subject. He once said: "I like a painting which makes me want to stroll in it, if it is a landscape, or to stroke a breast or back, if it is a figure."[22] On another occasion, he commented that he liked models whose "skin took the light." Although he painted the nude throughout his career, it became his principal theme from the mid-1880s on, when his interests shifted away from modern life to a new interest in the timeless and the classical. At the outset of his career, Renoir tackled the nude in his ambitious Salon submission *Diana* (fig. 54), the kind of standard subject with which an aspiring artist could make his mark at the Salon, although on this occasion this rather awkward studio set-piece, for which the artist's new mistress Lise Tréhot was the robust model, was unsuccessful. During the 1870s, Renoir was largely concerned with modern-life leisure subjects, but he nevertheless painted a few nudes of great beauty. *Nude in the Sunlight* (fig. 55), in which the play of dappled sunlight on the figure exemplifies Renoir's Impressionist style, caused a furor at the second Impressionist exhibition in 1876, provoking the outraged critic of *Le Figaro* to demand: "Would someone kindly explain to M. Renoir that a woman's torso is not a mass of decomposing flesh with the green and purplish blotches that indicate a state of complete putrefaction of the corpse."[23] *Small Blue Nude* (fig. 56), painted a couple of years later, is one of the most exquisite examples of Renoir's Impressionist nudes. In this modest, informal study, the luminous, pale flesh tones resonate against the loosely brushed blue drapery and the quick touches of russet and green that evoke the landscape setting.

After 1886, the female nude became Renoir's principal concern. Men are banished almost entirely from his work. His stay in Italy in the autumn of 1881 brought about a great change in his subjects and style. The art of the Italian Renaissance that he was able to study firsthand had a profound impact on him, which brought about a new interest in classical subjects and a radical change in his technique. Drawing on the example of Raphael, particularly the frescoes in the Villa Farnesina in Rome, and the Pompeian wall paintings in the Museo Nazionale in Naples (although his enthusiasm

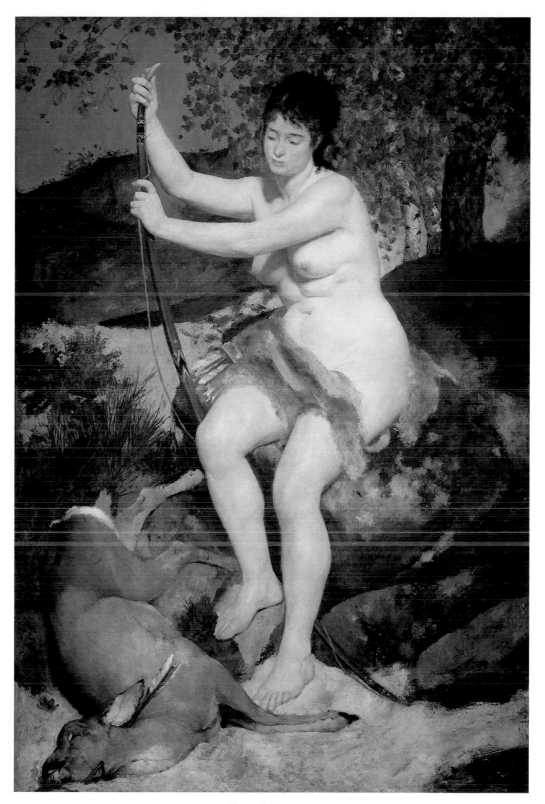

Fig. 54 *Diana*, 1867
Oil on canvas, 77 × 51¼ in. (199.5 × 129.5 cm)
National Gallery of Art, Washington, D.C., Chester Dale Collection

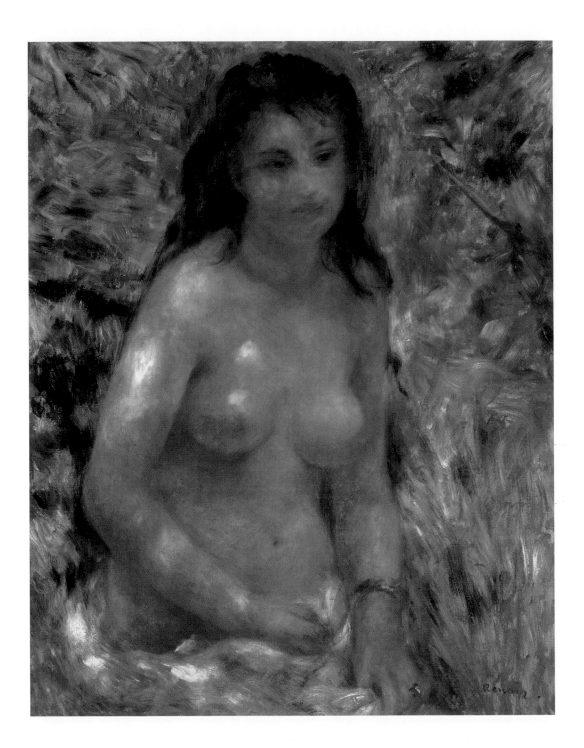

Fig. 55 *Nude in the Sunlight*, 1875–76
Oil on canvas, 31½ × 25¼ in. (81 × 65 cm)
Musée d'Orsay, Paris

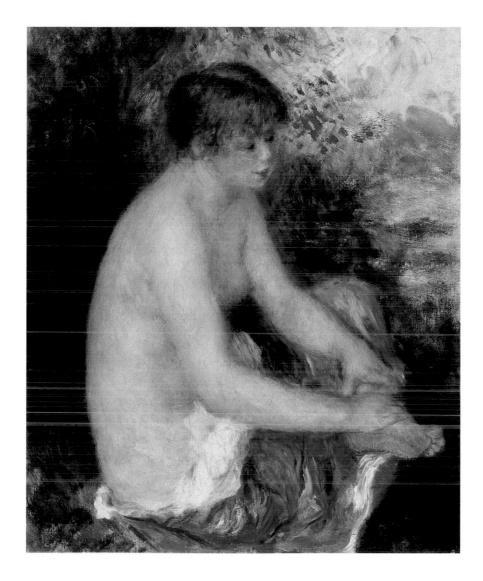

Fig. 56 *Small Blue Nude*, 1878–79
Oil on canvas, 17⁹⁄₁₆ × 15¹⁄₁₆ in. (46.4 × 38.2 cm)
Albright-Knox Art Gallery, Buffalo

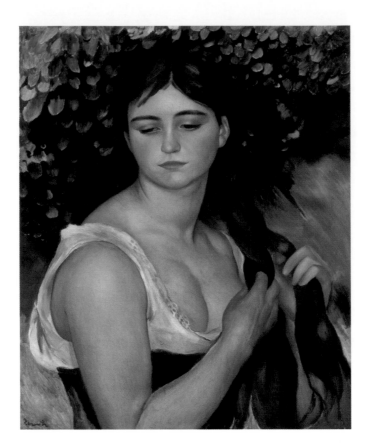

for the linearity of Ingres also played a part), he set about learning to draw and paint afresh, feeling that Impressionism was lacking in form, definition, and, therefore, seriousness. As a result, he introduced a linear precision into his work that is in direct opposition to the color-patch technique and loose brushwork of Impressionism. These experiments sometimes resulted in a curious mixture of styles in certain transitional works. For example, in *The Umbrellas* (fig. 8), Renoir's last modern-life painting, the figures on the right are painted in a loose, Impressionist technique while those on the left, painted after his return from Italy, are crisply defined with firm outlines. The work that can be seen as a manifesto of the new style (often referred to as Renoir's "dry" style) is the monumental *The Great Bathers* (fig. 59), with its sharply defined contours and smooth modeling, in which Renoir is clearly responding to Raphael but also to a relief by the seventeenth-century French sculptor François Girardon. These new ambitions can be seen as part of a more general reaction, shared by several of the original members of the Impressionist group in the 1880s, against the original tenets of

Fig. 57 *The Braid*, 1887
Oil on canvas, 22½ × 18½ in. (57 × 47 cm)
Museum Langmatt Stiftung Langmatt, Baden, Sidney and Jenny Brown

76

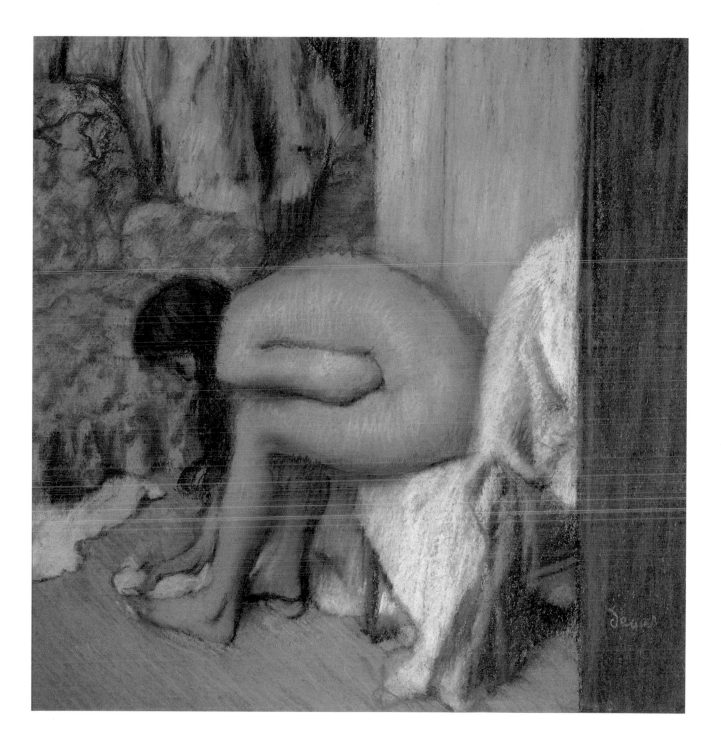

Fig. 58 Edgar Degas (1834–1917), *Nude Woman Drying Her Foot after the Bath*, 1885–86
Pastel, 21¼ × 20½ in. (54 × 52 cm)

Musée d'Orsay, Paris

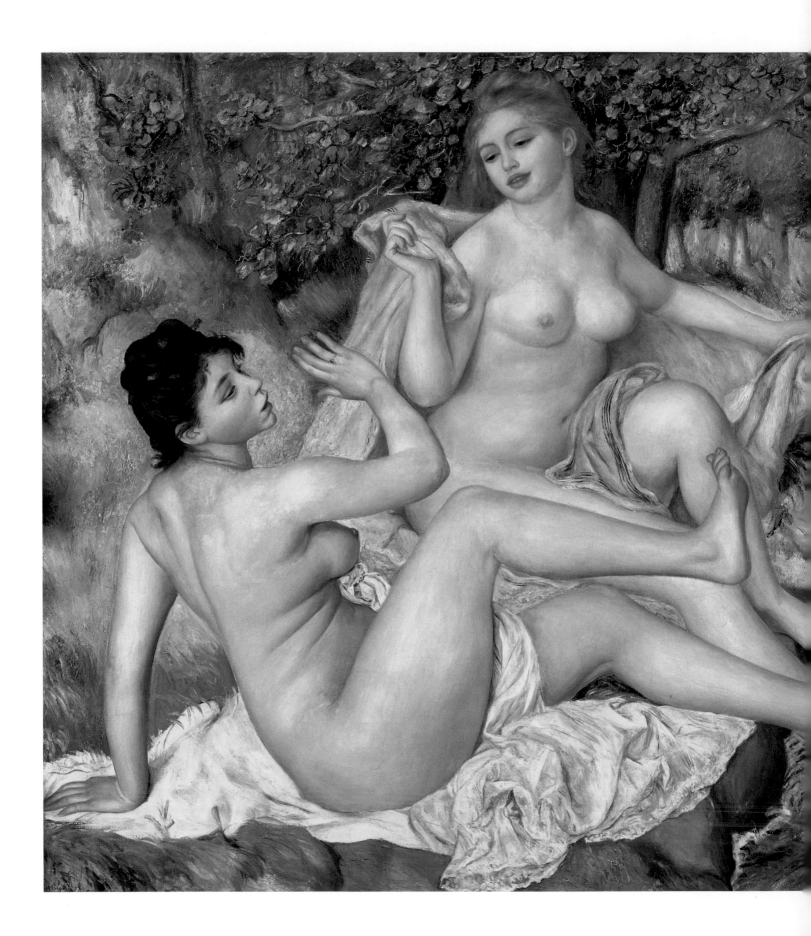

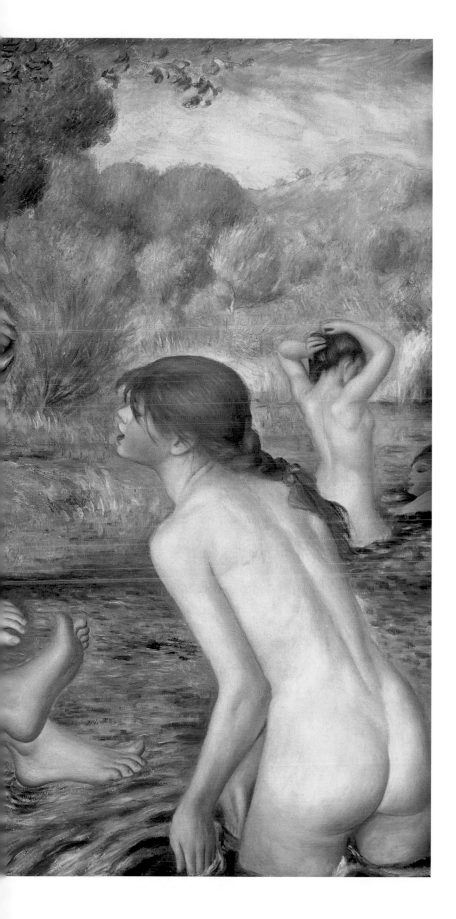

Fig. 59 *The Great Bathers*, 1884–87
Oil on canvas, 46⅜ × 67¼ in. (117.8 × 170.8 cm)
Philadelphia Museum of Art, The Mr. and Mrs. Carroll S. Tyson, Jr. Collection

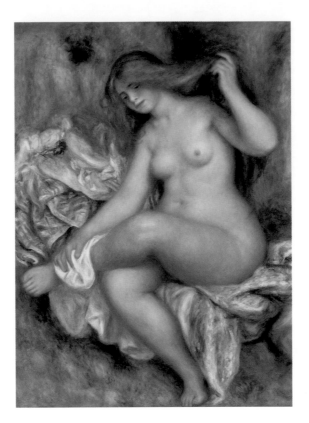

Impressionism. Renoir's interest in the female nude was paralleled by both Degas and Cézanne, and all three artists looked to the example of the old masters, particularly Titian, Veronese, and Rubens, as they sought to locate themselves, as mature artists, in the great tradition of post-Renaissance painting. But whereas Cézanne's powerful nudes assume an almost primitive force in his quest for an artistic arcadia, and Degas, who despised Renoir for embellishing his models,[24] investigates the unobserved awkwardness of women bathing (fig. 58), Renoir's nude models are pin-ups who passively and unambiguously invite the admiration of the male spectator (fig. 63).

By the 1890s, Renoir's hard-edged style yielded to a fluid melding of figure and ground, and particularities gave way to a more generalized and idealized approach, as in *Bather* (fig. 61). In his final years, although severely crippled by arthritis, Renoir, at Vollard's suggestion, branched out into the new dimension of sculpture with the aid of an assistant, the Spanish sculptor Richard Guino. The sculptures demonstrate his love of the Antique in such specifically mythological subjects as *Venus Victorious* (fig. 64) and *The Judgment of Paris*. In his last paintings, Renoir achieved

Fig. 60 *Seated Bather*, 1903–06
Oil on canvas, 45¾ × 35 in. (116.2 × 88.9 cm)
The Detroit Institute of Arts, Bequest of Robert H. Tannahill

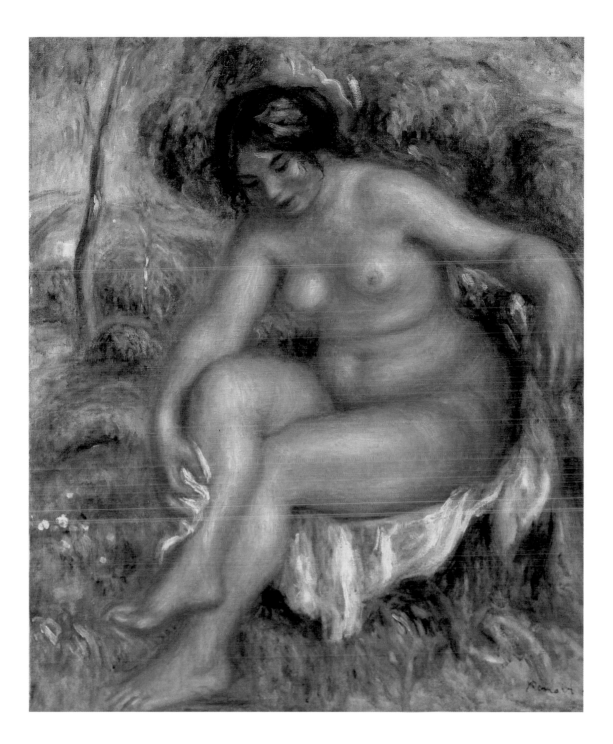

Fig. 61 *Bather,* 1912
Oil on canvas, 25¾ × 22 in. (65.4 × 55.9 cm)
Toledo Museum of Art, Purchased with funds given by Mrs. C. Lockhart McKelvy

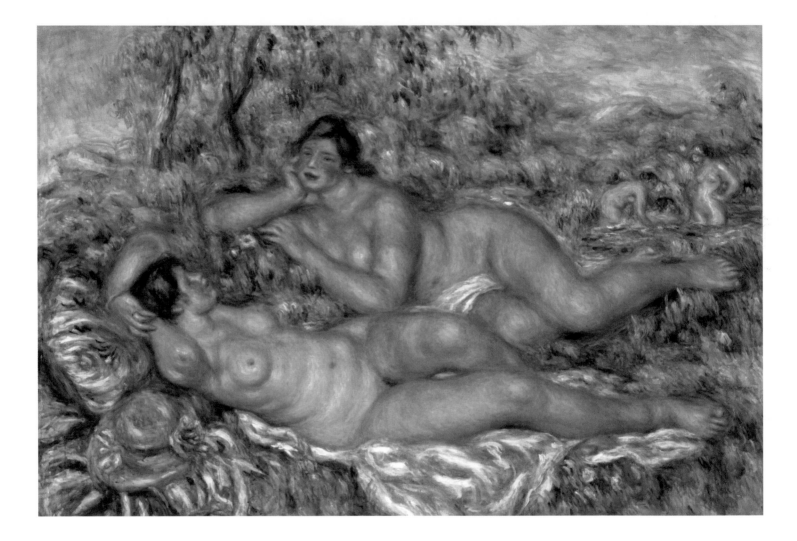

Fig. 62 *The Bathers*, *c.* 1918–19
Oil on canvas, 43⁵⁄₁₆ × 63 in. (110 × 160 cm)

Musée d'Orsay, Paris

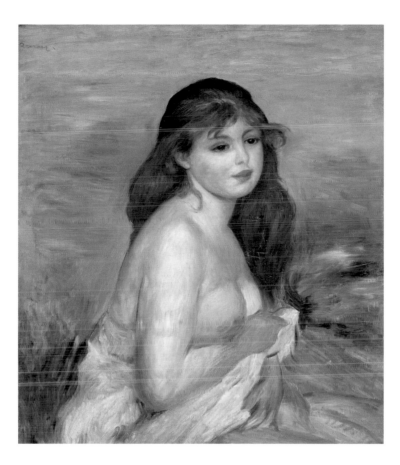

Fig. 63 *Bathing Woman*, c. 1885–86
Oil on canvas, 23⅝ × 21¼ in. (60 × 54 cm)
National Museum of Art, Architecture and Design, Oslo

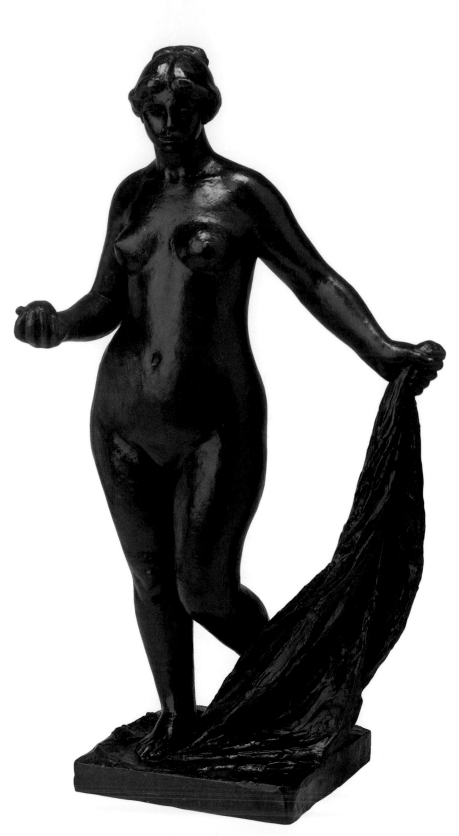

Fig. 64 *Venus Victorious*, 1914
Bronze, 23¾ × 12¼ × 7¾ in. (60.3 × 31 × 19.7 cm)
Hirshhorn Museum and Sculpture Garden, Washington, D.C., Gift of Joseph H. Hirshhorn

an extraordinary technical flowering. The vibrating surfaces of late works by Titian and Rubens's handling of translucent paint provided an inspiration to the aging artist as he sought his ideal of an earthly paradise suffused with warm reds, oranges, and pinks, an effect he created by floating thinly diluted washes of oil paint over a white ground, creating iridescent rainbows of colors. It was by his images of women that Renoir wished to be judged as an artist. His late works, in which the resplendent nudes represent a mythical ideal of woman, fused with the earthly paradise that Renoir always sought, are a fitting final testament (fig. 62).

NOTES

1. Jean Renoir, *Renoir*, Paris (Hachette) 1962, p. 86.
2. See Tamar Garb, "Renoir and the Natural Woman," *The Oxford Art Journal*, 8:2, 1985, pp. 3–15; Anthea Callen, "Renoir: the Matter of Gender," *Renoir: Master Impressionist*, exhib. cat., ed. by John House, Sydney (Queensland Art Gallery) 1994, pp. 41–56.
3. Jean Renoir, *Renoir*, 1962, p. 88.
4. Jean Renoir, *Renoir*, 1962, p. 89.
5. Georges Rivière, *Mr. Degas, bourgeois de Paris*, Paris (Floury) 1935, p. 18.
6. Edmond Renoir 1879, in L. Venturi, *Les Archives de l'Impressionnisme. Lettres de Renoir, Monet, Pissarro, Sisley et autres. Mémoires de Paul Durand-Ruel*, Documents, I, II, Paris and New York (Editions Durand-Ruel) 1939, p. 337.
7. Jean Renoir, *Renoir*, 1962, p. 203; Julie Manet, *Journal (1893–1899)*, Paris 1979, pp. 143, 150.
8. Douglas W. Druick *Renoir; the Artist in Focus*, Chicago (Art Institute of Chicago) 1997, p. 35.
9. Jean Renoir, *Renoir*, Paris 1962, p. 151; *Renoir's Portraits: Impressions of an Age*, exhib. cat., ed. Colin Bailey, Anne Distel, Linda Nochlin, Ottawa, Chicago, and Fort Worth 1997–98, New Haven CT and London (Yale University Press) 1997, p. 134.
10. Jean Renoir, *Renoir*, 1962, p. 198, 310–11.
11. Jean Renoir, *Renoir*, 1962, p. 198.
12. See Anne Distel in *Renoir*, exhib. cat., essays by John House, Anne Distel, Lawrence Gowing, London, Paris and Boston 1985–86, New York (Abrams) 1985, p. 182.
13. Ambroise Vollard *Renoir: An Intimate Record*, transl. Harold L. van Doren and Randolph T. Weaver [1925], republished New York (Dover Publications) 1990, p. 47.
14. Getty Center for the History of Art and the Humanities, Santa Monica CA, Special Collections, Renoir to Congé, February 1, 1896, cited in *Renoir's Portraits: Impressions of an Age* 1997, p. 224, p. 326, note 3.
15. See *Renoir's Portraits: Impressions of an Age* 1997, p. 236.
16. See *Renoir's Portraits: Impressions of an Age* 1997, p. 236 and p. 330, note 18 for Renoir's comment to Vollard, recorded in Ambroise Vollard, *La Vie et l'oeuvre de Pierre-Auguste Renoir*, Paris (A. Vollard) 1919, p. 129.
17. Vollard 1990, p. 53. See *Renoir: Master Impressionist* 1994, p. 126.
18. See Roger Benjamin, *Renoir and Algeria*, New Haven CT and London (Yale University Press) 2003 for an excellent study of Renoir and Orientalism.
19. Renoir's copy is in the Worcester Art Museum, Worcester MA.
20. Ambroise Vollard 1990, quoted in Diane Kelder, *The Great Book of French Impressionism*, New York (Abbeville Press) 1992, p. 255.
21. See Benjamin 2003, p. 88.
22. Albert André, *Renoir*, Paris (G. Cress) 1928, p. 42.
23. Albert Wolf, "Le Calendrier parisien," *Le Figaro*, April 3, 1876.
24. Rivière 1935, p. 24.

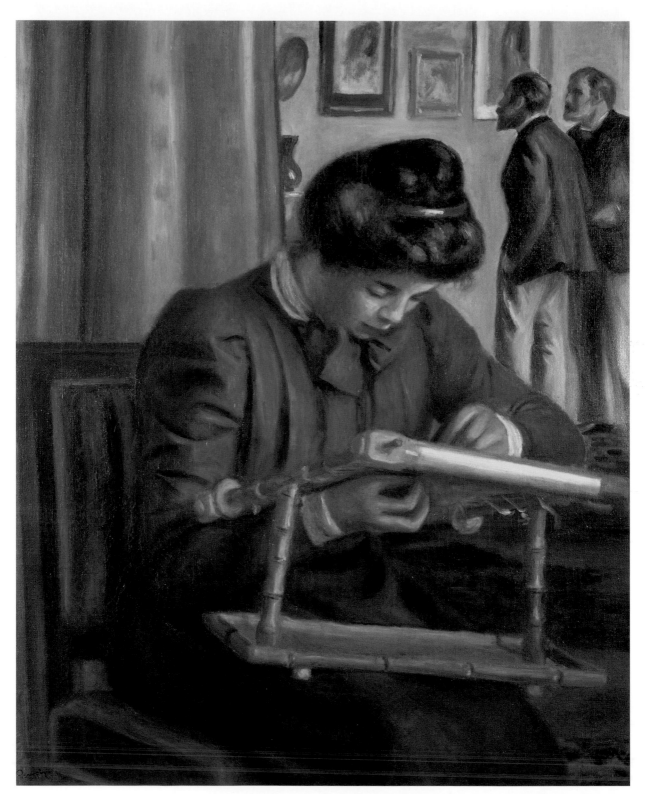

Fig. 65 *Christine Lerolle Embroidering, c.* 1895–98
Oil on canvas, 32⅛ × 25⅞ in. (82.5 × 65.8 cm)
Columbus Museum of Art, Gift of Howard D. and Babette L. Sirak, the Donors to the Campaign for Excellence, and the Derby Fund

"CHRISTINE LEROLLE EMBROIDERING"
Between Genre Painting and Portraiture

JOHN COLLINS

T he remarkable *Christine Lerolle Embroidering* (fig. 65) holds a particularly important position in Renoir's œuvre. It is a testament to Renoir's warm relationship with the Lerolle family, reflects his interest in old master traditions, and embodies values of contentment, craft, and creativity. It is also an extraordinarily tender image drawn from a casual observation of daily life in the Lerolle household. Christine's father, the academic Salon artist Henry Lerolle, views his art collection in the background with the Belgian sculptor Louis Devillez. In contrast to Christine's strongly modeled and boldly colored foreground presence, the men hover behind in subdued tones of gray and black, thereby privileging the youthful and contemplative female sphere over the animated and critical one of the male.

Since the model and setting are beyond doubt, the painting is usually discussed today as a portrait.[1] However, Renoir's choice of subject, the embroiderer, or "*la brodeuse*," is one with a long history. In seventeenth-century Holland it was frequently the subject of genre painting, the art-historical term assigned to the depiction of everyday life. Renoir's reference to this rich tradition would not have been lost upon his contemporaries. As John House has pointed out in his discussion of Renoir's

La Promenade (1870; J. Paul Getty Museum, Los Angeles), during the nineteenth century titles played an important role in giving meaning to a genre subject.[2] *Christine Lerolle Embroidering* was first exhibited simply with the title *La Brodeuse* in 1902 at the Durand-Ruel gallery in Paris, and has long been considered a pendant to *Breakfast at Berneval* of 1898 (fig. 66).[3] Here the gender emphasis is reversed and the artist's son Pierre sits in the foreground in a mirrored pose with a book in his lap, while a woman and child play in the background; reading is also a common genre subject. It is the purpose of this essay to examine how the categories of portrait and genre are interwoven in Renoir's *Christine Lerolle Embroidering*, reflecting a particularly Impressionist strategy that, as Leila Kinney has described, "tried at once to avoid the benign universals of genre and to refuse the proper name of portraiture."[4]

Just as genre painting was drifting toward stale and hollow parody in the nineteenth century, the Impressionists rejuvenated the tradition through a fresh observation of the everyday world around them. In scenes of modern life in the home, in cafés, theaters, racetracks, the street, and the dance hall they discovered a compelling immediacy and emotional complexity. Indeed, as genre painting emerged as the new history painting, the familiar faces of those included in the Impressionist circle begin to take on the allegorical role once fulfilled by gods and heroes. Renoir was particularly adept at achieving vitality in paintings of everyday life by rooting his subjects in actual situations, defined settings, and the actions and routines of known individuals, all of which carried meaning for the contemporary viewer. His 1876 masterpiece *Dance at the Moulin de la Galette* (fig. 67) is a good example of a genre painting that borrows from the conventions of portraiture in order to convey a more convincing reality, adding a cultural relevance that is all but lost today. As I have argued elsewhere, this defining image of Parisian leisure depicts a well-known Parisian landmark, which became notorious as a center of Republican insurrection during the civil war that ended the Commune government in May 1871.[5] Rather than hire models, Renoir shows young women from the community, the Montmartroises Jeanne and Estelle, as well as his own bohemian circle of writers and artists who frequented the establishment. *Dance at the Moulin de la Galette* is no fictional scene but rather a celebration of Montmartre's distinctiveness within the urban matrix of Paris.

Given that Renoir drew upon the familiar to lend credence to the general

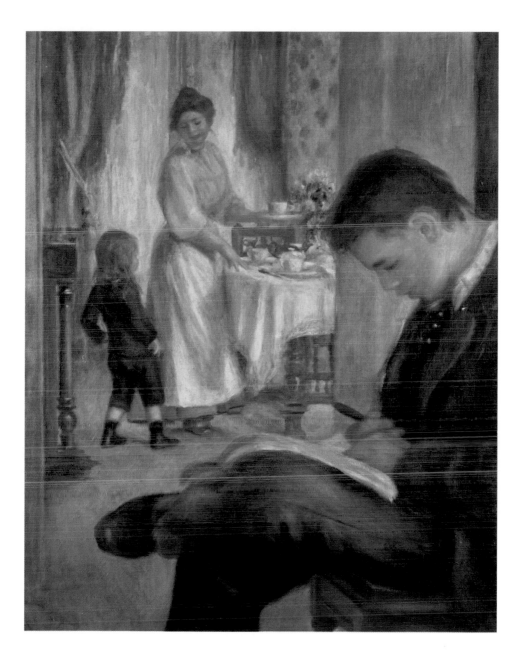

Fig. 66 *Breakfast at Berneval*, 1898
Oil on canvas, 32 × 26 in. (82 × 66 cm)

Private collection

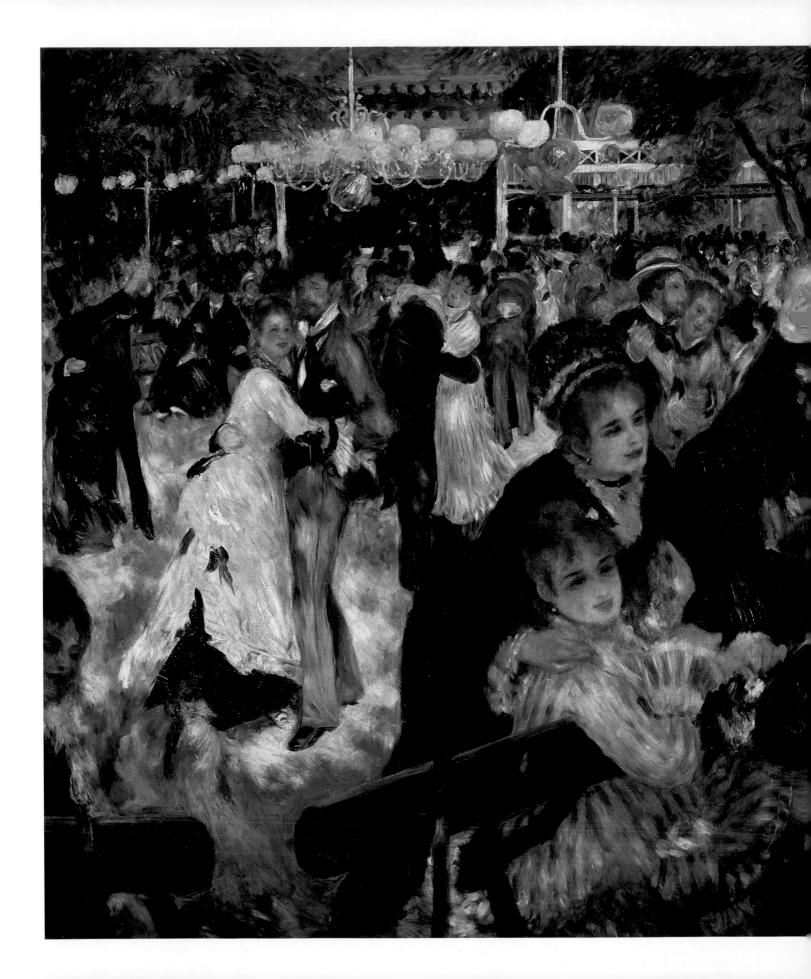

Fig. 67 *Dance at the Moulin de la Galette*, 1876
Oil on canvas, 51½ × 69 in. (131 × 175 cm)
Musée d'Orsay, Paris

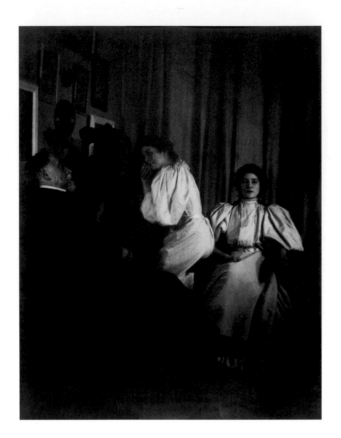

themes of genre painting, it is necessary to examine Christine Lerolle and her family and why it would be important for the artist to associate them with the subject of embroidery. Christine was raised in a strict Catholic household where the arts were the topic of passionate conversation. In the living-room where she sits, located at 20, avenue Duquesne in the fashionable 7th arrondissement of Paris, Christine was introduced to the most celebrated artists, musicians, and writers of the time in France. Guests included the painters Edgar Degas, Albert Besnard, Maurice Denis, Henri Fantin-Latour, and Renoir, the writers Stéphane Mallarmé, André Gide, Maurice Bouchor, and Adrien Mithouard, and the composers Vincent d'Indy, Claude Debussy, and Ernest Chausson, Christine's uncle. Recitals hosted by the Lerolles were legendary. In her home, Christine heard Debussy's first thoughts for the opera *Pelléas et Mélisande* and saw Vincent d'Indy perform the finale for his opera *Fervaal*.[6]

The juxtaposition of art and music in a salon setting in *Yvonne and Christine Lerolle at the Piano* (fig. 70) parallels that of embroidery and art in *Christine Lerolle*

Fig. 68 Edgar Degas (1834–1917), *Self-Portrait with Christine and Yvonne Lerolle*, 1895–96
Gelatin silver print, 10 × 8 in. (25.4 × 20.3 cm)
Musée d'Orsay, Paris

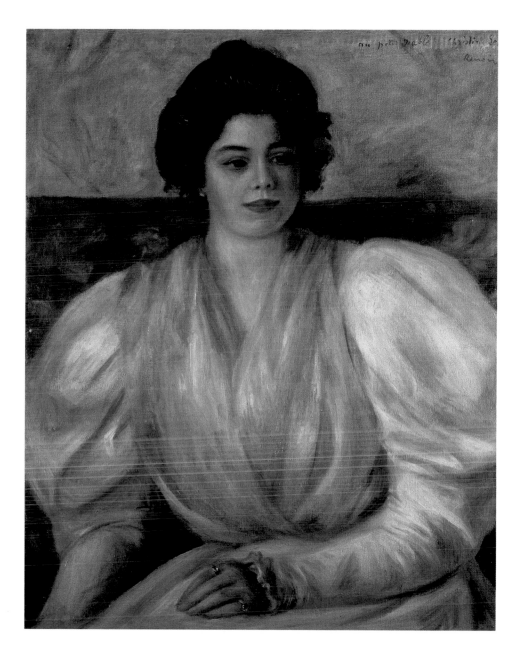

Fig. 69 *Christine Lerolle* (detail), 1897
Oil on canvas, 26½ × 21 in. (57.5 × 53.5 cm)
Private collection

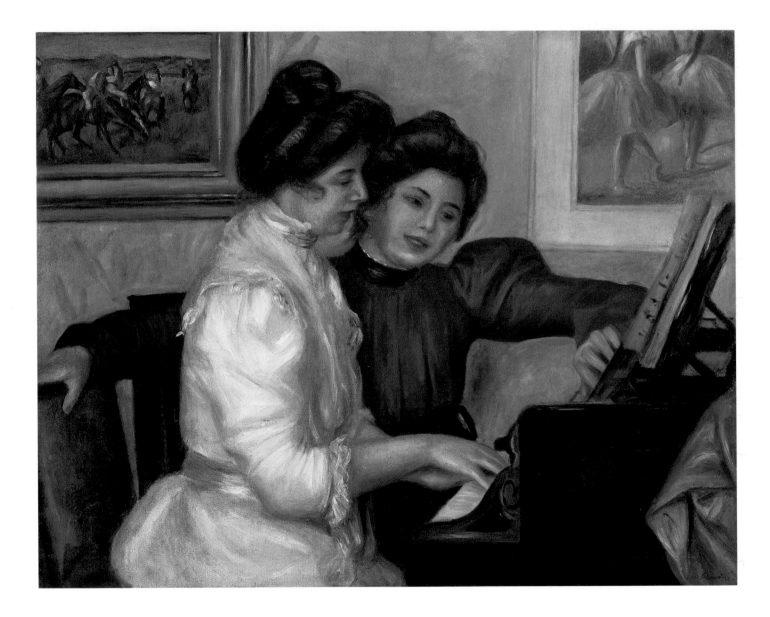

Fig. 70 *Yvonne and Christine Lerolle at the Piano*, c. 1897
Oil on canvas, 29 × 36 in. (73 × 92 cm)

Musée de l'Orangerie, Paris

Embroidering. Music in France during the 1890s was as much a part of the currency of cultural politics as painting and the decorative arts. Inspired by the growing popularity of the Germanic operas of Richard Wagner, French composers such as Chausson and Debussy sought to assert French national traditions. Henry Lerolle played an active part in supporting new French music through his salon gatherings, by promoting Chausson's music in such paintings as *The Organ* (The Metropolitan Museum of Art, New York), exhibited to acclaim at the Salon of 1885, and by his participation in the founding in 1894 of the *Schola Cantorum*, a school of liturgical song.[7] It is significant that Renoir chose the theme of music for *Young Girls at the Piano* (Musée d'Orsay, Paris), the painting purchased in 1892 by the Musée du Luxembourg, a museum devoted to leading living artists. The presence of music in the Lerolle household prompted Renoir to return to the theme five years later with *Yvonne and Christine Lerolle at the Piano*. Here again we see the fine line that Renoir draws between portraiture and genre. While grounded in the familiar, this painting makes an equally poignant comment about the value of music in daily life. One can easily imagine that Yvonne is playing one of the pieces from *Images (Oubliées)* that Debussy dedicated to her in 1894.

Yvonne Lerolle may have been the more accomplished piano player and the favored model of Maurice Denis, but Renoir clearly had a fond attachment to Christine.[8] How different in presentation and mood is the painting of Christine wearing a dress of pink chiffon with puffed white silk sleeves (fig. 69).[9] With its emphasis on her startling beauty, it functions unquestionably as a portrait. Renoir presented the painting to Christine in apparent compensation for her supporting role beside Yvonne at the piano, and for modeling services in *Christine Lerolle Embroidering*, where her attractive facial features are partially concealed by her pose and clearly secondary to the genre subject. The portrait captures a warmth of character together with what Maurice Denis described as the "delicious" nature of Christine and Yvonne, which they had both inherited from their mother, Madeleine Escudier.[10] Renoir indicated the date 1897 and inscribed it as a gift, "*au petit diable*" ("to the little devil"), which suggests something of the sitter's playful relationship with the painter. Edgar Degas was a third artist to immortalize the enchanting looks of the Lerolle sisters, in a series of photographs he took in the living-room of their Paris apartment (fig. 68).[11]

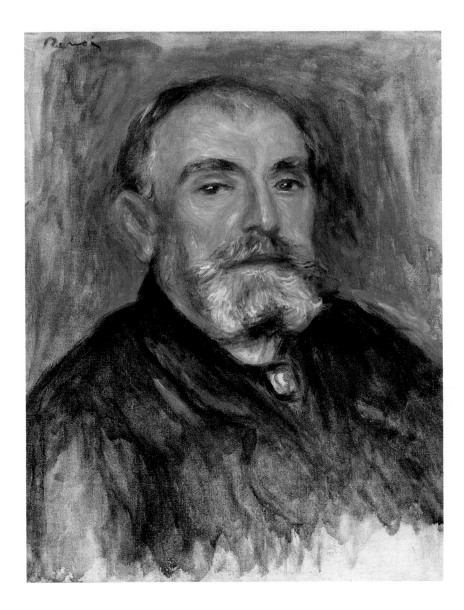

Fig. 71 *Portrait of Henry Lerolle, c.* 1895–97
Oil on canvas, 18⅛ × 13¾ in. (46 × 35 cm)

Private collection

Christine sits dispassionate and upright facing the camera, while Yvonne rests her head on Rodin's bronze sculpture of *Ugolino*, next to Degas himself. Christine's appearance in these photographs seems rather austere and distant and recalls the mystical side of her personality, as known from family history. [12]

Through marriage and bonds of friendship the Lerolles occupied a central position in a family dynasty closely allied with Renoir, Degas, and the Impressionist circle. Degas encouraged Christine's marriage to the Catholic activist and publisher Louis Rouart on February 12, 1901.[13] Christine's marriage followed that of Yvonne in 1898 to another Rouart son, the agricultural engineer Eugène. Rouart *père*, Henri, was a wealthy industrialist who also painted and became an early supporter of the Impressionists.

Henry Lerolle moved easily from Impressionist circles to the conservative world of the academic establishment. He had been exhibiting successfully at the annual Paris Salon since 1868 and in 1889 was awarded the prestigious Légion d'Honneur, the French government's recognition of individuals who make outstanding contributions to society.[14] Renoir is careful to include the red ribbon of the Légion d'Honneur on Lerolle's lapel in *Christine Lerolle Embroidering*. The award was given the year in which Lerolle completed *The Crowning of Science*, a mural commission for the Hôtel de Ville, and had also been a judge for the prestigious exhibition of French art mounted for the Exposition Universelle in Paris for which the Eiffel Tower was built. Known as a "*café au lait*" painter because of his monochromatic color schemes inspired by Dutch art, Lerolle favored religious subject-matter for personal preference.[15] Nevertheless, he appears to have been exceptionally broad-minded in his collecting tastes and was well positioned to exercise influence on behalf of the Impressionists and the Nabis, a group of younger artists interested in the expressive possibilities of decorative painting. The Lerolles began collecting work by Edgar Degas as early as 1878, and eventually owned nine works by the artist, including *Before the Race* (1882; Sterling and Francine Clark Art Institute, Williamstown MA) and *Pink Dancers*, a pastel of 1878 (Norton Simon Art Foundation, Pasadena CA), both of which appear in Renoir's *Yvonne and Christine Lerolle at the Piano*.[16] In 1889, Lerolle acquired a painting of Martinique by the Nabis' mentor, Paul Gauguin, who complained about the low price paid, 300 francs, but recognized that entry into the collection of this "*artiste officiel*" provided enviable

exposure to the potential collectors who passed through his apartment.[17] For example, in 1890 Lerolle's brother-in-law, Ernest Chausson, purchased a second Martinique landscape.[18] Nabi artist Maurice Denis shared Lerolle's fervent Catholicism and became somewhat of a protégé of the elder artist. The two met in 1891, and Lerolle acquired five major works by Denis, including *Catholic Mystery* (1890; private collection).[19]

Renoir's relationship with the Lerolle family and his painting *Christine Lerolle Embroidering* coincide with a crucial period in the mid-1890s when Impressionist painting was beginning to find support in official circles in France. His introduction to the Lerolles by Berthe Morisot in November 1894 followed by only months his appointment as the executor of the estate of artist Gustave Caillebotte.[20] Lerolle would have lent a sympathetic ear to Renoir's difficulties in convincing the Musée du Luxembourg to accept Caillebotte's collection of Impressionist painting. The eventual display of the collection in February 1897 marked the first time that such artists as Paul Cézanne, Claude Monet, and Edgar Degas were seen in a museum devoted to contemporary French art. It was during this year that Renoir was closest to the Lerolle family. In 1897, he painted *Christine Lerolle Embroidering* as well as *Christine Lerolle*, and *Yvonne and Christine Lerolle at the Piano* is usually assigned to the same year. The undated portrait of Henry formerly in the Fondation Rau may also date to 1897 (fig. 71). Certainly it was painted after Lerolle met Renoir in late 1894 and likely before the furor caused by the Dreyfus Affair in early 1898, which found the two men with opposing views.[21] Originally Renoir had included a vertical border of roses along the left-hand side of Henry Lerolle's portrait, a highly unusual embellishment, as the rose was a signature motif reserved almost exclusively for images of women. This border unfortunately disappeared between 1960 and 1973 when the portrait left the family collection and went to auction.[22] One cannot help but conclude, however, that the roses were a highly respectful addition, a salute to shared ideals and to Lerolle's elegant and cultivated artistic sensibility, characterized by Maurice Denis as "delicate, sensual, feminine in the sense that he painted what he loved."[23]

Renoir's arduous three-year diplomatic effort on behalf of the Caillebotte collection coincided with a renewed respect on his part for museums and the old masters they contained. Indeed, *Christine Lerolle Embroidering* was painted at a time when the legacy of Impressionism and how it related to past traditions was of deep

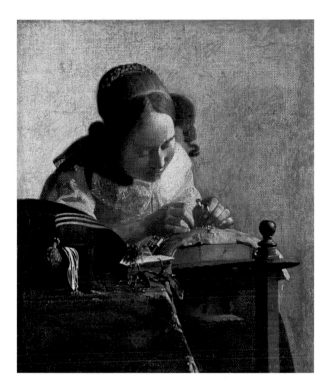

concern to Renoir. In particular, Jan Vermeer became something of an obsession during the 1890s. In Vermeer's novel treatment of natural light, spontaneous representation of everyday life, and sensitivity to male and female spheres of experience, Renoir discovered a confirmation of his own Impressionist enterprise. In July 1896, he abandoned Gustave Caillebotte's brother, Martial, in Bayreuth after becoming bored with Wagner's *Ring* cycle, and took a train to Dresden to see Vermeer's *The Courtesan* (1656; Gemäldegalerie, Alte Meister, Dresden).[24] He also spoke of the great charm of Vermeer during a visit to the Louvre with Jeanne Baudot, his student from 1893 to 1895. In her biography of the artist, Baudot recorded: "He particularly liked [Gerard] Terborch and [Pieter] de Hooch, but his favorite was *The Lacemaker* by Vermeer."[25] Purchased by the Louvre in 1870, *The Lacemaker* (fig. 72) remained the museum's only work by the artist until 1983. In 1894, it was given a central position in a major rehang of the Dutch and Flemish galleries of the Louvre, which may have been a contributing factor to Renoir's interest in the artist.[26] With her total absorption in her task and the sense of domestic industry, the theme of the embroiderer in Vermeer and other Dutch painters, such as Nicolas Maes, is closely associated with notions of

Fig. 72 Jan Vermeer (1632–1675), *The Lacemaker, c.* 1669–70
Oil on canvas laid down on wood, 9½ × 12¼ in. (24 × 31 cm)
Musée du Louvre, Paris

spiritual and contemplative virtue. The Bible that sits on the table beside the model's sewing container in Vermeer's *The Lacemaker* highlights this aspect.[27] The religious nature of the embroiderer or sewing subject can be found earlier in Northern Renaissance depictions of the Annunciation.[28]

In painting *Christine Lerolle Embroidering*, it is as though Renoir was creating his own "Vermeer," the influence of whom is evident not only in the serene contentment with which Christine carries out her task, the attention to the position of the hands and fingers, but also in the informality of the pose, facing toward the right. Christine has her hair neatly pulled up, just as the hair of Vermeer's model is carefully tied back, so as not to interfere with her work. One can also imagine Renoir taking a keen professional interest in Vermeer's use of natural light, a real innovation at a time when Rembrandtesque chiaroscuro was still very much in vogue; the importance of it can be seen in *The Lacemaker* as an indirect source from a nearby window. It is revealing of Renoir's mellowed Impressionist aesthetic in the mid-1890s that, while *Christine Lerolle Embroidering* is set indoors, the painting's lively color intensity results from bright outdoor lighting. The heavy olive-toned curtain hanging behind Christine suggests that she sits near a window. An indirect natural light source is also apparent in Renoir's *Claude and Renée* of 1903, with its glowing whites and soft, pastel-like browns mingled with yellow hues (fig. 73).

During the eighteenth century in France, embroidery subjects enter the repertoire of artists in innovative and surprising ways, anticipating Renoir's merging of genre and portraiture. The hushed realism of Dutch genre painting influenced such works as Jean-Siméon Chardin's *The Diligent Mother* (1740; Musée du Louvre, Paris), where a mother and daughter examining a work of embroidery take on a pedagogical role of moral guidance in the spirit of Jean-Jacques Rousseau's *Emile, or On Education* of 1762. With the introduction in the eighteenth century of the embroidery frame into portraiture, the traditional formality of the portrait diminishes, the line between the public and private persona is drawn less distinctly, and the sitter becomes identified with the exemplary virtue of domestic industry. For example, Jacques-André-Joseph Aved's *Portrait of Madame Crozat*, exhibited at the Salon of 1741 (Musée Fabre, Montpellier), shows the wife of one of the king's financiers at her embroidery frame and is unusual for its intimate familiarity with someone of a very high rank in society.

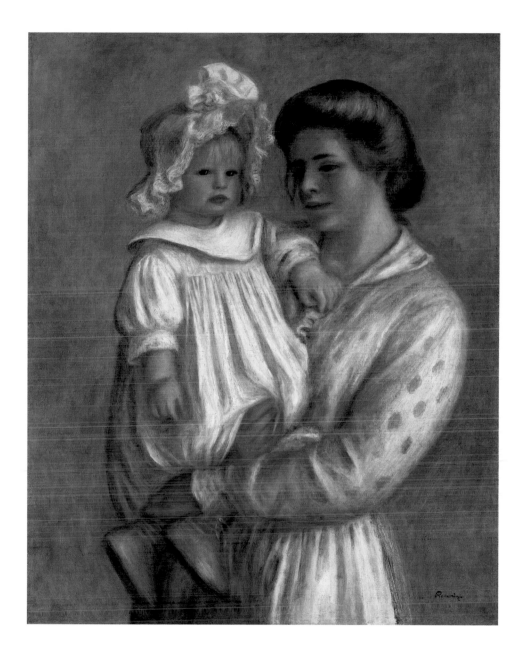

Fig. 73 *Claude and Renée*, 1903
Oil on canvas, 31 × 25 in. (78.7 × 63.5 cm)
National Gallery of Canada, Ottawa

François-Herbert Drouais's *Madame de Pompadour at Her Embroidery Frame* (1763–64; The National Gallery, London) seems rather more staged for effect and propaganda value. As Louis XV's mistress, Madame de Pompadour lived in apartments at Versailles and held a powerful and highly public position in the royal court. Not only does embroidery identify her as someone capable of sensitive domesticity, but the activity also suits her role as a refined patron of the arts. Madame de Pompadour's love of the craft was such that contemporaries described her as receiving ambassadors while seated at the embroidery frame.[29]

The embroiderer theme was among a range of domestic genre subjects, such as the reader, the music recital, mother and child, dressing, and games, that were carried over into the nineteenth century and given a new sense of contemporaneity and psychological insight by the Realists and the Impressionists. Henri Fantin-Latour, a friend of both Henry Lerolle and Renoir, was an artist who successfully bridged tradition and modernity in his genre painting, primarily by using his immediate family and friends as models. His *Two Sisters* (1859; Saint Louis Art Museum) transforms the embroidery theme into a moment of brooding intimacy in the domestic life of his siblings. Fantin returned dramatically to the embroidery theme for his submission to the Salon of 1881 in the single-figure painting *La Brodeuse* (private collection). This painting looks forward to *Christine Lerolle Embroidering* in the way in which it pares down the leisure activity to its essentials of solitude and self-absorption. The model is again from Fantin's inner circle, being his sister-in-law, Charlotte Dubourg, a teacher of German, whose fine features appear often in his work.

The subject of embroidering or sewing is second only to that of music recitals and reading in Renoir's repertoire of images depicting the daily life of the bourgeois woman in France. One of his early examples, *Lise Sewing* (1866–68; Dallas Museum of Art, The Wendy and Emery Reves Collection), portrays his mistress and frequent model Lise Tréhot. While Lise could also take on the persona of sultry odalisque or nude bather, here she appears in a profoundly tender moment of domestic peace. Most remarkable about Renoir's treatment of embroidery from the 1870s is the way he is able to energize this traditionally subdued indoor subject with a brilliant flourish of Impressionist light and color. The model of his *Young Woman Sewing* (1879; The Art Institute of Chicago), for example, undertakes her task attentively and calmly in a

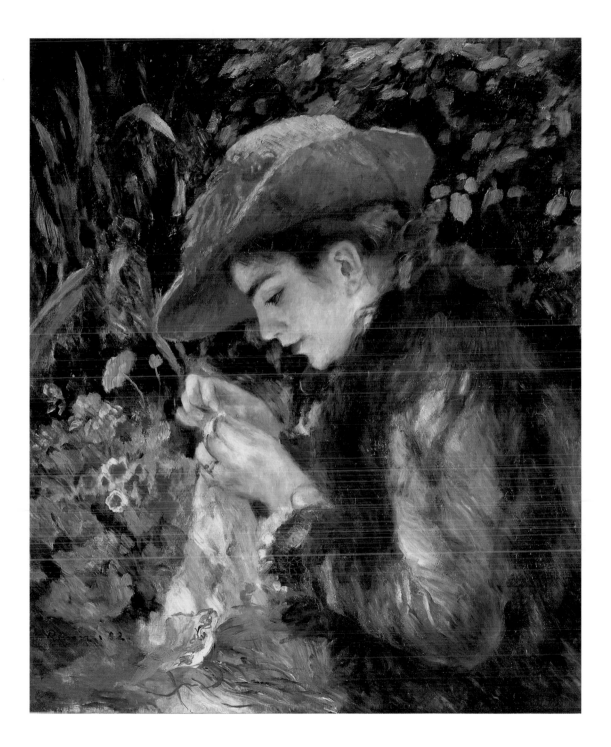

Fig. 74 *Marie-Thérèse Durand-Ruel Sewing*, 1882
Oil on canvas, 25½ × 21³⁄₁₆ in. (64.8 × 53.8 cm)

Sterling and Francine Clark Art Institute, Williamstown MA

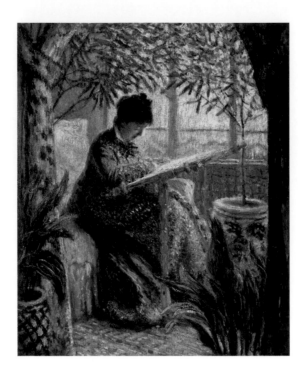

tranquil scene bathed with natural light. A bouquet of flowers next to her offers a further opportunity to enliven the color. The painting shows Renoir as a dazzling master of Impressionist light, though as he came to terms with the old masters over the next decades, both this exuberant color and the outright technical virtuosity would find more tamed means of expression. For a portrait commission a few years later, *Marie-Thérèse Durand-Ruel Sewing* (fig. 74), which was painted as he was entering a period of stronger modeling and controlled lighting, Renoir places his model against the backdrop of a verdant summer garden. The sun is bright enough to require Marie-Thérèse to wear a hat while she works and allows Renoir to maintain a palette of rich, pure pigments, especially in the skin tones, without distracting from the beauty and gentle concentration of the sitter.

Renoir was not alone among Impressionist artists to discover in the embroidery theme a source of inspiration for both portraits and genre painting. A charming example in portraiture is Claude Monet's loving portrayal of his first wife, Camille Doncieux, sitting at an embroidery frame in the sun porch of their Argenteuil home in the winter of 1875 (fig. 75). There is a similar warmth of personality to that sensed in *Christine Lerolle Embroidering*, the same itemization of the details of daily life that

Fig. 75 Claude Monet (1840–1926), *Madame Monet Embroidering*, 1875
Oil on canvas, 25⅝ × 21⅝ in. (65 × 55 cm)
The Barnes Foundation, Merion PA

allow one to identify the work as a portrait, but it also looks forward to Renoir's later painting in the way a relationship is established between the act of embroidery and decoration. The Monets' interest in interior furnishings can be seen in the sensitivity shown to plantings, floor coverings, and curtains, as well as in the Turkish kaftan worn by Camille, which is most likely embroidered. Camille appears in the same kaftan in two earlier paintings by Renoir. The first shows her reclining on a sofa with white cushions reading *Le Figaro* and is assigned a date of 1872 (Calouste Gulbenkian Foundation, Lisbon). About a year later the kaftan is worn again to captivating effect in the beautiful *Camille Monet Reading* (c. 1873; Sterling and Francine Clark Art Institute, Williamstown MA). In addition to its novel elevated viewpoint, this painting clearly illustrates an astute awareness of the latest trends in contemporary design, particularly exotic fabrics, and the emerging taste in *Japonisme*, evident in the *uchiwa* (fans) on the wall.

Renoir's example of enriching modern genre painting with references to past traditions to create timeless records of experience endeared him to the Nabis group, which rose to prominence during this crucial period in the 1890s when *Christine Lerolle Embroidering* was painted. Nabi artist Maurice Denis was already a protégé of Henry Lerolle when he wrote glowingly of Renoir's 1892 retrospective in the pages of *La Revue blanche*, a journal closely associated with the group.[30] The editor of that journal, Thadée Natanson, praised Renoir's "religious enthusiasm" for the old masters in a lengthy article of 1896.[31] In the Nabis Renoir at last found a sympathetic ear for his long held desire to revive the tradition of collaborative artistic projects involving painters, sculptors, and decorative artists, including embroiderers. Paul-Elie Ranson produced designs for embroidery and tapestry. Another member, Edouard Vuillard, featured the craft in *Tapestry*, or *The Embroiderers* (The Museum of Modern Art, New York), part of an ensemble of decorative paintings commissioned in 1895 by Natanson for his Paris apartment. As Guy Cogeval has remarked, Vuillard has transformed this casual encounter of women embroidering into an allegory of creation itself.[32] It is likely that Renoir knew of Vuillard's commission, and it may have prompted his decision to paint *Breakfast at Berneval* as a pendant to *Christine Lerolle Embroidering*.

The artwork of Odilon Redon was also concerned with the nature of creativity and artistic inspiration. In his pastel portrait of Christine's aunt, *Madame Arthur*

Fontaine (fig. 76), embroidery serves the same allegorical purpose as it did in Vuillard's painting, but is here treated with an unusual degree of mystic sensuality.[33] The effervescent yellow of her dress positively exudes contentment, while the floral bouquet that envelops the model magically "embroiders" the painting and enhances the joyful mood. Born Marie Escudier, Madame Fontaine was an accomplished piano player, whose recitals with Debussy offered yet another opportunity for the Lerolle sisters to be immersed in the leading music of the time.[34] Like *Christine Lerolle Embroidering*, Redon's portrait was inspired by a close friendship with the model. Both were members of an élite group who gathered frequently at the home of Ernest Chausson, Marie's brother-in-law, with the Lerolles, Mallarmé, Denis, and André Gide.[35] Describing Renoir, perhaps during one of these evenings, Redon wrote in 1896 that "he was plain spoken; we got on well together. He kept all his tenderness inside, but one guesses it."[36] Arthur Fontaine was a wealthy engineer and powerful bureaucrat who was close to the Lerolle circle until his divorce in 1909.[37]

These comparisons help to situate *Christine Lerolle Embroidering* in a modernist context where genre and portrait traditions have merged and provocative new layers of meaning have been added to this age-old theme. They also raise the question of the distinction between sewing as a domestic chore, or simply repair work, and the leisure activity of decorative embroidery. There is an ambiguity about what kind of sewing is undertaken by Lise Tréhot or the anonymous model of Renoir's *Young Woman Sewing*, in The Art Institute of Chicago. Are they mending a dress or piece of clothing, or embellishing it with patterned stitching? Clothing and fabric repairs were carried out by domestics or hired out to seamstresses. During the 1870s, Renoir often employed as models the working-class women of Montmartre, who most likely took sewing work for income. Decorative embroidery, however, was reserved for a leisured class and aimed primarily at domestic objects and dress. In France, the *Journal des Demoiselles*, which prided itself on publishing articles about the proper upbringing of young women, regularly included embroidery patterns among its plates in the 1880s.[38] As reflected in the work of the Nabis, however, by the 1890s embroidery had become associated with a more far-reaching interest in the importance of the arts in everyday life.

The British designer William Morris was an important impetus behind this change. Morris included embroidery along with furniture, ceramics, metalwork, and

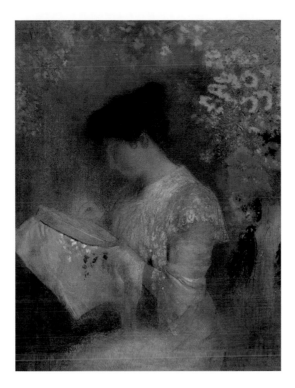

tapestry as part of the decorative arts known as the Arts and Crafts Movement. Morris's influence was widespread on the Continent. In France, the Art Nouveau gallery of Siegfried Bing exhibited fabrics and wallpapers by Morris from 1895 and by the turn of the century had begun producing its own embroidery and tapestries.[39] Embroidery also figured prominently among the decorative arts exhibited by the Belgian avant-garde exhibition society Les XX from 1892, and in Germany the Jugendstil designer Hermann Obrist ran an embroidery workshop in Munich from 1894.[40]

It is significant that Maurice Denis identified the wallpaper in the Lerolles' apartment as designed by William Morris, as it shows they were sympathetic to the ideals of the Arts and Crafts Movement.[41] Renoir includes traces of what appears to be Morris's "Willow" pattern in *Yvonne and Christine Lerolle at the Piano*. The ceramic vase displayed against the wall in *Christine Lerolle Embroidering* suggests that Henry Lerolle also collected decorative arts along with paintings. Renoir's voluminous writings on the decorative arts demonstrate how ardently he shared Morris's vision of reviving crafts and decorative arts based on artistic principles. In 1884, he had been

Fig. 76 Odilon Redon (1840–1916), *Madame Arthur Fontaine (Marie Escudier)*, 1901
Pastel on paper, 28½ × 22½ in. (72.4 × 57.2 cm)
The Metropolitan Museum of Art, New York, The Mr. and Mrs. Henry Ittleson Jr. Purchase Fund

careful to include embroiderers in his prospectus for a "Society of Irregularists," whose members would also include painters, architects, goldsmiths, and decorators.[42] This idea had strong parallels with the Impressionist group as an independent exhibiting society that stressed the individual creativity of its members and the acceptance of handmade imperfection as a sign of originality. In 1911, *L'Occident*, a Catholic nationalist journal, published Renoir's preface to Cennino Cennini's *Libro dell'arte*, a Renaissance painting manual, in which Renoir argued for greater attention to the crafts.[43]

A more ambitious scale of activity is suggested in Renoir's *The Embroiderers* of 1902 (fig. 77), which may depict an embroidery workshop compatible with the Arts and Crafts Movement's call to revive the craft of artistic needlework. At this time *La Grande Encyclopédie* reported: "Each day embroidery takes on a greater importance; in Paris and Lyon an industry has developed which emphasizes artistic imagination and to which artists have devoted their talent. From a purely social point of view this tendency should be encouraged as it brings more work for the single woman and allows families to work together in a moral and remunerative occupation."[44] Here the meditative solitude of *Christine Lerolle Embroidering* or Redon's *Madame Arthur Fontaine* is absent. The model sitting at the embroidery frame converses with her companion, who looks on attentively as if about to comment. A third woman stands behind them clutching a piece of cloth in her hands, as if examining the stitching. Compared to the comfortable Lerolle apartment, the room in which these women work has no remarkable features, but that suits the lack of formality with which the women are dressed. Their loose-fitting clothing seems appropriate for long hours at the embroidery frame and their hair is tied back hastily.

Given Renoir's engagement with decorative arts and the Nabis, and his particular sensitivity to embroidery as part of a broader movement of design reform as early as 1884, the choice of such a subject in *Christine Lerolle Embroidering*, while fulfilling the role of portrait, is not without implications about the role of art in society. This reading of the painting as addressing a current moral issue adds to those meanings already embedded in the genre tradition of the embroiderer, which praise the joy of creation and the virtue of silent application to one's task. The fact that Christine Lerolle is the model and her father is shown in the background not only shows a warm affection for the family, but also co-opts Lerolle as an ally in this enlightened social

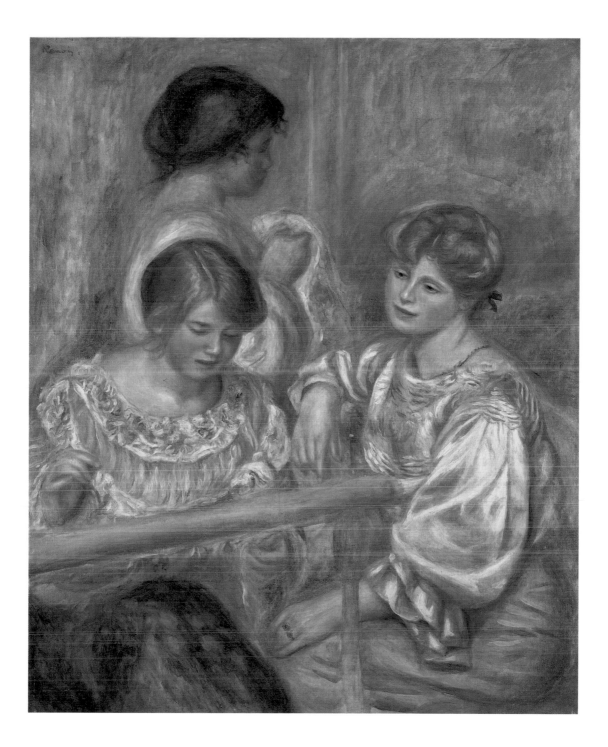

Fig. 77 *The Embroiderers*, 1902
Oil on canvas, 39¾ × 32⅛ in. (101 × 81.6 cm)

The Barnes Foundation, Merion PA

vision. As treated by Renoir, embroidery becomes an affirmation of cultural traditions and old master prototypes, but moves beyond mere genre painting to evoke an allegorical world in which the female represents contentment, companionship, and creativity, truly in the sense of Gustave Geffroy's perceptive comment on Renoir's work in 1894 as "a source of enchantment for the eye, a consolation, and balm for the spirit."[45]

NOTES

1. See the entry for the painting in *Renoir's Portraits: Impressions of an Age*, exhib. cat., ed. Colin Bailey, Anne Distel, Linda Nochlin, Ottawa, Chicago, and Fort Worth 1997–98, New Haven CT and London (Yale University Press) 1997, pp. 227–28.

2. John House, *Pierre-Auguste Renoir. La Promenade*, Los Angeles (Getty Museum Studies on Art) 1997, pp. 25ff. See also his insightful discussion of genre and portraiture distinctions, "Impressionism and the Modern Portrait," in *Faces of Impressionism: Portraits from American Collections*, exhib. cat., by Sona Johnston, Baltimore Museum of Art, 1999, pp. 11–35.

3. *Tableaux par A. Renoir*, exhib. cat., Paris, Galeries Durand-Ruel, June 1902, no. 20, as 1897. *Breakfast at Berneval* possibly follows as no. 21, *La lecture* (*The Reader*), though the date of 1897 would be erroneous. The two were related as pendants by Michel Drucker, *Renoir*, Paris (Editions Pierre Tisné) 1955, p. 67.

4. Leila W. Kinney, "Genre: A Social Contract?" *Art Journal*, XLVI, no. 4, Winter 1987, p. 268.

5. John Collins, *Seeking l'esprit gaulois: Renoir's* Bal du Moulin de la Galette *and aspects of French social history and popular culture*, Ph.D. diss., Montreal, McGill University, 2001.

6. Maurice Denis, "Henry Lerolle et ses amis," *La Revue de Paris*, November 1, 1930, p. 95, also published as a book in 1932.

7. Maurice Denis, "Henry Lerolle et ses amis," *La Revue de Paris*, November 1, 1930, p. 95. See also Lois Dinnerstein, "Beyond Revisionism: Henry Lerolle's 'The Organ,'" *Arts Magazine*, LIV, no. 5, January 1980, pp. 172–76, and the forthcoming correspondence between Lerolle, Ernest Chausson, and Maurice Denis, Insitut de Recherche sur le Patrimoine Musical en France, Paris, 2006.

8. Maurice Denis, *Portrait of Yvonne Lerolle in Three Guises*, (1897; private collection).

9. This painting is documented in *Catalogue of Important Impressionist and Modern Drawings, Paintings and Sculpture*, Christie, Manson and Woods, London, June 28, 1968, lot no. 95.

10. Maurice Denis, "Henry Lerolle et ses amis," *La Revue de Paris*, November 1, 1930, p. 93.

11. Four of the series not illustrated only recently came to light and all five were sold at Drouot Richelieu auctions in Paris, July 2, 2004, lots 212–16.

12. In conversation with Mme. Camille Imlay, Christine Lerolle's granddaughter.

13. *Renoir's Portraits: Impressions of an Age* 1997, p. 227; see Lerolle family tree reproduced in *Au coeur de l'impressionnisme: La famille Rouart*, exhib. cat., Paris, Musée de la Vie Romantique, 2004, p. 189; I would also like to thank M. Jean-Marie Rouart for his comments and to note his chapter on Louis Rouart, his grandfather, in *Une famille dans l'impressionisme*, Paris (Gallimard) 2001.

14. "Henry Lerolle'" in *Dictionnaire critique et documentaire des peintres, sculpteurs, dessinateurs et graveurs*, new edn, Paris (Gründ) 1999, VIII, p. 553. Despite his increasing importance, there is still no recent study of the work and career of Henry Lerolle. Other biographical sources include *Beyond the Easel: Decorative Painting by Bonnard, Vuillard, Denis and Roussel*, exhib. cat., by G. Groom, Art Institute of Chicago, 2001, pp. 41–45, and G. Weisberg, "Madame Henry Lerolle and Daughter Yvonne," *The Bulletin of the Cleveland Museum of Art*, December 1977, pp. 326–43.

15. Maurice Denis, "Henry Lerolle et ses amis," *La Revue de Paris*, November 1, 1930, p. 100.

16. Henry and his wife, Madeleine Escudier, visited his studio to buy two works, *Women Combing Their Hair*, (*c.* 1875; The Phillips Collection, Washington, D.C.) and *Dancer with Arms behind Her Head*, (1873; private collection). See *Degas*, exhib. cat., by J.S. Boggs *et al*, Ottawa, National Gallery of Canada, 1988, p. 232, as inscribed by Mme Lerolle.

17. Gauguin to Théo van Gogh, July 1, 1889, in Douglas Cooper (ed.), *Paul Gauguin: 45 Lettres à Vincent, Théo et Jo van Gogh* (Collection Rijksmuseum Vincent van Gogh, Amsterdam), 's-Gravenhage (Staatsuitgeverij) and Lausanne (Bibliothèque des Arts) 1983, p. 101.

18. Daniel Wildenstein, *Gauguin: A Savage in the Making. Catalogue Raisonné of the Paintings 1873–1888*, Paris (Wildenstein Institute) 2001, II, p. 333.

19. *Maurice Denis 1870–1943*, exhib. cat., Amsterdam, Van Gogh Museum 1994, nos. 9, 15, 34, 40, and 103.

20. Renoir to Morisot, November 21 1894, declining an invitation to dinner with the Lerolles, in *Correspondance de Berthe Morisot*, Paris (Quatre Chemins Editart) 1950, p. 183.

21. French army officer Alfred Dreyfus, of Jewish descent, was falsely accused of passing military secrets to the Germans in 1894, though evidence emerged subsequently that pointed to another officer, who was acquitted of treason in 1898. This prompted the writer Emile Zola to write *J'accuse* in support of Dreyfus and galvanized French opinion. Unusually for one of his Catholic loyalties, Lerolle became a pro-Dreyfusard like Zola, while Renoir remained anti-Dreyfusard; see Maurice Denis, "Henry Lerolle et ses amis," *La Revue de Paris*, November 1, 1930, p. 103.

22. Reproduced with border in the sale cat. of Galerie Charpentier, Paris, June 17 1960, no. 101*bis*, and without in *Impressionist and Modern Paintings, Drawings and Sculpture*, Christie's, London, March 27 1973, no. 50.

23. Maurice Denis, "Henry Lerolle et ses amis," *La Revue de Paris*, November 1, 1930, p. 97.

24. Vollard 1990, pp.106–07, and the chronology in *Renoir*, exhib. cat., by J. House and A. Distel, London (Arts Council of Great Britain) 1985, p. 307.

25. Jeanne Baudot, *Renoir, ses amis, ses modèles*, Paris (Editions littéraires) 1949, p. 29.

26. Eugène Richtenberger, "La caisse des musées," extract from *La Revue bleue*, 10, March and April 1894, footnote p. 35.

27. *Vermeer and the Delft School*, exhib. cat., by W.A. Liedtke, New York, The Metropolitan Museum of Art, 2001, p. 178.

28. See, for example, the engraving of the *Annunciation* (1594) by Henrik Goltzius, where the Virgin is shown kneeling with her sewing basket nearby.

29. *Madame de Pompadour et les arts*, exhib. cat., by X. Salmon, Paris, Réunion des Musées Nationaux, 2002, p. 162.

30. Maurice Denis, "L'Exposition Renoir," *La Revue blanche*, June 25, 1892, pp. 365–66.

31. Thadée Natanson, "Renoir," *La Revue blanche*, June 15 1896, pp. 545–51.

32. *The Time of the Nabis*, exhib. cat., by Guy Cogeval, Montreal, Museum of Fine Arts, 1998, pp. 120–21.

33. See entry for the work in Alec Wildenstein, *Odilon Redon: Catalogue raisonné de l'œuvre peint et dessiné*, Paris (Wildenstein Institute) 1992, I, p. 45.

34. A. Salomon, *Vuillard: The Inexhaustible Glance*, Paris (Wildenstein Institute) 2003, II, p. 696.

35. See, for example, Chausson's invitation cited in S. Mallarmé, *Correspondance*, Paris (Gallimard) 1959–1985, IX, p. 81.

36. Redon to Maurice Fabre [1896], cited in S. Monneret, *L'impressionnisme et son époque*, Paris (Denoël) 1978–1981, II, p. 177.

37. See entry for Édouard Vuillard, "Arthur Fontaine Reading in His Salon, 1904," in Richard Shone, *The Janice H. Levin Collection of French Art*, New York, The Metropolitan Museum of Art, 2002, p. 35. For divorce date see Alec Wildenstein, *Odilon Redon: Catalogue raisonné de l'œuvre peint et dessiné*, Paris (Wildenstein Institute) 1992, I, p. 45. note 33.

38. See, for example, the monthly issues of *Journal des Demoiselles*, Paris (Bureau du Journal), XLIX, 1881.

39. G. Weisberg, *Art Nouveau Bing: Paris Style 1900*, New York (Abrams) 1986, p. 143.

40. N. Pevsner, *Pioneers of Modern Design from William Morris to Walter Gropius*, 2nd edn, New York (The Museum of Modern Art) 1949, p. 60–62.

41. Maurice Denis, "Henry Lerolle et ses amis," *La Revue de Paris*, November 1, 1930, p. 93.

42. Robert L. Herbert, *Nature's Workshop: Renoir's Writing on the Decorative Arts*, New Haven CT (Yale University Press) 2000, p. 109.

43. Reprint with analysis in Herbert 2000, pp. 158ff.

44. Alfred Ernst, La Bibliothèque Ste-Geneviève, "La broderie," *La Grande Encyclopédie*, Paris (H. Lambrault) 1886–1902, VIII, p. 100.

45. Gustave Geffroy, "Auguste Renoir," *La Vie artistique*, 1894, cited in Nicolas Wadley (ed.), *Renoir: A Retrospective*, New York (Hugh Lauter Levin) 1987, p. 187.

Fig. 78 *Self-Portrait, c.* 1875
Oil on canvas, 15⅜ × 12½ in. (39.1 × 31.7 cm)

Sterling and Francine Clark Art Institute, Williamstown MA

PIERRE-AUGUSTE RENOIR: CHRONOLOGY

JESSIE TURNER

1841

February 25: Pierre-Auguste Renoir is born in Limoges, France, the sixth of seven children. His father, Léonard Renoir, is a tailor; his mother, Marguerite Merlet, is a dressmaker.

1844

The Renoir family moves to Paris, to 16, rue de la Bibliothèque.

1854–58

Renoir ia apprenticed to a porcelain painter, M. Levy, and also attends drawing classes at the Ecole gratuite de dessin.

1855

Living at 23, rue d'Argenteuil (1st arrondissement), which will remain the family address until 1868.

c. 1858–59

Paints fans and colors coats of arms for his brother Henri, who is a medal engraver. After his apprenticeship, works as a decorator for M. Gilbert, a manufacturer of blinds, at 65, rue du Bac off the boulevard Saint Germain.

1860

January 24: Registers to work as a copyist in the Louvre; will renew his registration annually until 1864.

1861

Studies at Charles Gleyre's studio, meeting Monet, Sisley, and Bazille. November 8: Gleyre requests authorization for him to work in the print rooms of the Bibliothèque Impériale.

1862

Moves out of home and rents a series of rooms and studio spaces in Paris. April 1: Admitted to the Ecole Impériale et Spéciale des Beaux-Arts, where he will study until 1864. Possibly this summer paints in Fontainebleau forest with Sisley and Monet. October–December: Completes three months of military service.

1863

Supposedly submits a painting to the Salon (*A Nymph with a Faun*), which he destroys upon its refusal. Meets Pissarro and Cézanne, who are studying at the Académie Suisse.

1864

January 5–March 5: Two further months of military service. May–June: Exhibits for the first time at the Salon (*La Esmeralda*), after which he destroys the painting.

1865

May–June: Exhibits again at the Salon (*Summer's Evening*). Through the painter Jules Le Coeur, meets Lise Tréhot, who will be his mistress and favorite model until 1872. Summer:

Visits Fontainebleau with artist friends from Gleyre's studio.

1866

April: Submits a painting and a sketch to the Salon. Withdraws his submission when the painting is refused, not wishing to be represented by only a sketch.

1867

Moves in with Bazille at 20, rue Visconti near the Ecole des Beaux-Arts, where they are later joined by Monet, who is in financial straits. Submission to the Salon of *Diana* (fig. 54) is rejected.

1868

Moves with Bazille to new rooms in the 17th arrondissement, near the Café Guerbois, which Manet and his circle frequent. The Salon's acceptance of *Lise (Woman with a Parasol)* (fig. 11) brings him some publicity. His parents move west of Paris to Voisins Louveciennes.

1869

Shows one painting at the Salon (*Summer, study*). Over the summer, visits Monet very frequently at Saint-Michel near Bougival, and they paint together at La Grenouillère.

1870

May–June: Shows two paintings at the Salon (*Bather*, now know as *Bather with a Griffon*, and *Odalisque*, fig. 47). July 19: War is declared with Prussia. August 26: Called up to serve in the Cavalry. November 28: Bazille is killed near Beaune-la-Rolande.

1871

Sent to fight in Libourne, but becomes very ill with dysentery and recovers in nearby Bordeaux. Demobilized in March and returns to Commune-controlled Paris.

1872

Parisiennes in Algerian Dress is rejected by the Salon, but he attracts the interest of the dealer Paul Durand-Ruel, who buys his work for the first time. April 24: Lise marries an architect.

1873

Rejected by the Salon. May–June: Exhibits two works at the Salon des Refusés (*Riding in the Bois de Boulogne* and *Portrait*). Vacations in the summer with Monet at Argenteuil and in the autumn rents rooms and a studio south of Montmartre at 35, rue Saint Georges. Involved in plans for an alternative exhibiting society, and on December 27 the "Société anonyme coopérative des artistes, peintres, sculpteurs, graveurs etc." is founded. Meetings, attended by Manet, Monet, Degas, Pissarro, Sisley, and Cézanne, are often held at the rue Saint Georges.

1874

April–May: Contributes six pictures, including *The Theater Box* (fig. 23), *The Parisienne* (fig. 3), and a pastel, to the society's first exhibition at 35, boulevard des Capucines near the Opéra. The exhibitors are nicknamed "Impressionists" by critics. December 22: His father dies. Frequents the Nouvelle-Athènes Café throughout the 1870s with Manet, Duranty, Duret, Rivière, and Cézanne, among others.

1875

March 24: Puts his work up for public auction, having persuaded Monet, Sisley, and Morisot to join him in a sale at the Hôtel Drouot, and sells twenty paintings. There are public demonstrations when the works go on show. April: Rejected by the Salon. He meets the collector Victor Chocquet, who becomes a major patron, and in 1875–76 paints several portraits of Chocquet's family members (see *Madame Victor Chocquet*, fig. 24).

1876

April: Contributes fifteen paintings to the second Impressionist exhibition. Over the summer paints at his studio on rue Cortot (18th arrondissement) and at the Moulin de la Galette. Probably meets the publisher Georges Charpentier and his wife around now, and from about 1876 to 1884 will receive many portrait commissions from the couple and their circle (see *Madame Georges Charpentier and Her Children*, fig. 25).

1877

April: Exhibits twenty-one works, including *Dance at the Moulin de la Galette* (fig. 67), at the third Impressionist Exhibition. May 28: Organizes a second public sale of Impressionist work at the Hôtel Drouot and sells fifteen paintings and a pastel.

1878

May–June: Exhibits at the Salon with *At the Café* (fig. 4). *Les Peintres impressionnistes* is published by Duret and Zola's *L'Assommoir* is also published, illustrated with woodcuts after drawings by various artists, including Renoir (fig. 15).

1879

April–May: Refuses to exhibit at the fourth Impressionist exhibition. May–June: Shows at the Salon, including *Madame Georges Charpentier and Her Children* (fig. 25) and a portrait of the actress Jeanne Samary. June: Small solo show at the offices of *La Vie moderne*, one of Charpentier's new publications, and will exhibit twice more at the offices this year. Having met the Berards through Charpentier, he stays, possibly for the first time, at their home in Wargemont, Normandy, and paints *The Wave*, *The Gypsy Girl* (fig. 36), and *View of the Coast near Wargemont*.

1880

January: Breaks his right arm and keeps himself occupied by working with his left hand. April: Does not take part in the fifth Impressionist exhibition. May–June: Exhibits at the Salon. Early summer: Visits the Berards in Wargemont and works on various portrait commissions in July. September–October: Stays on the Île de Chatou with the Fournaise family, painting *The Luncheon of the Boating Party* (fig. 39) at their restaurant. Probably meets Aline Charigot, a young seamstress, who models for him.

1881

From January: Paintings purchased more regularly by Durand-Ruel. March–April: Goes to Algeria, meeting up with artist friends Lhote, Lestringuez, and Cordey. April–May: Does not take part in the sixth Impressionist exhibition; goes on to show two works at the Salon. July and September: Vacations at Wargemont. Late October: goes to Italy, traveling to Venice, probably to Padua and Florence, and to Rome (where he is greatly impressed by Raphael's frescoes), Naples, Capri, and Sicily. Joined by Aline Charigot for the last part of the trip. Manet is made Chevalier de la Légion d'Honneur.

1882

Returning from Italy stays in l'Estaque near Marseille and works with Cézanne. Has pneumonia in February. Refuses to lend to the seventh Impressionist exhibition but cannot prevent Durand-Ruel from sending twenty-five Renoirs that he owns. March–April: To Algeria on doctor's advice, where he stays for about six weeks, painting figure pictures. May–June: Exhibits one work at the Salon.

1883

April: Renoir retrospective of seventy works at 9, boulevard de la Madeleine (1st arrondissement), one in a series of solo Impressionist exhibitions organized by Durand-Ruel from February to June. May: Durand-Ruel shows three Renoirs in the United States. May–June: One work exhibited at the Salon. September–October: Visits the Channel Islands. December: Takes a short trip with Monet along the Mediterranean coast, visiting Cézanne on the return journey. Manet dies in this year.

1884

May: The Union Générale collapses, threatening Durand-Ruel with bankruptcy. With Monet, encourages Durand-Ruel to sell his work off cheaply. Plans to found a new painters' association ("La Société des irrégularistes") and to publish an abridged "*Grammaire des arts*," for which he enlists the help of a relation of Pissarro's. Leaves rue Saint Georges with Aline Charigot sometime in 1884 for the hill of Montmartre.

1885

March 21: First son, Pierre, is born at 18, rue Houdon, and Caillebotte is godfather. Summer: Hires a house at La Roche-Guyon and paints with Cézanne. September–October: First visit to Aline's home in Essoyes, in the Champagne region. The family moves to nearby rue Laval, now rue Victor Massé. Winter: Attends social gatherings organized by Morisot and is introduced to Stéphane Mallarmé and other writers.

1886

January 11: Morisot admires the *Motherhood* (fig. 40) and

bather pictures in his atelier. April–June: A Durand-Ruel show at the American Art Galleries and the National Academy of Design in New York includes thirty-eight paintings and pastels by Renoir. May: Does not contribute to the eighth and final Impressionist exhibition. June–July: Has five paintings in the fifth Exposition Internationale at Georges Petit's gallery on rue de Sèze. August–September: Tours and paints in northern Brittany with Monet.

1887

May–June: Second exhibition organized by Durand-Ruel at the National Academy of Design, New York, includes five paintings by Renoir. Exhibits five paintings at Petit's sixth Exposition Internationale, including *The Great Bathers* (fig. 59).

1888

February: The family visits the Cézannes in Aix. Summer: Paints at Argenteuil and Bougival. A letter from Pissarro to his son states that Renoir feels everyone is against him in his attempts to move away from his "romantic period." Autumn: To Essoyes (*Washerwomen* and *Grape Pickers at Lunch*), remaining there until the end of the year. Temporarily afflicted by facial paralysis after a cold spell in late December.

1889

The family address is given at 11, boulevard Clichy, near Montmartre. Unhappy with recent work, refuses to take part in the Centennial exhibition planned as part of the Exposition Universelle. Summer: Rents a house near Aix from Cézanne's brother-in-law and paints landscapes.

1890

April 14: Marries Aline Charigot. May: Refuses a decoration. May–June: Shows for the last time at the Salon (*The Daughters of Catulle Mendès*, 1888). Vacations in Mézy with Morisot and Eugène Manet.

1891

July: Solo exhibition, *Renoir, tableaux de 1890–91*, at Durand-Ruel's in Paris. Based in Paris over the summer, and makes frequent trips to Mézy to visit Eugène Manet and Morisot, introducing them to Aline. Mallarmé's prose poem *Le Tiroir de Laque* is published as *Pages*. Its only illustration is an etching for the frontispiece by Renoir.

1892

April: Mallarmé engineers the State's purchase of a version of *Young Girls at the Piano* (1892). May: Major Renoir retrospective (110 works) at Durand-Ruel's, with a catalogue preface by Arsène Alexandre. May 6: Hosts a dinner at the Café Riche to celebrate the show, with Mallarmé, Monet, Caillebotte, and Duret among the guests. Late May–June: Travels to Madrid, where he greatly admires Velàzquez, Goya, and Titian in the Prado, and to Seville. Late 1892: Paints Mallarmé's portrait.

1893

Makes trips along the Mediterranean coast and to Normandy and Essoyes, and is with his family at Pont-Aven in August. Takes on a pupil this year, Jeanne Baudot.

1894

February 21: Caillebotte dies and Renoir is his executor. He leaves about sixty works from his collection to the State, and a work to Renoir of his choice (chooses Degas's *Dance Lesson*). March: Attempts to persuade the State to accept the bequest. August: Gabrielle Renard, Aline's cousin, joins the household in Paris. September 15: Jean, his second son, is born at 13, rue Girardon (18th arrondissement). September–October: Severe attack of rheumatism while painting at Versailles. December: Dreyfus is convicted; Renoir will remain staunchly anti-Dreyfusard during all that follows. Possibly meets the dealer Ambroise Vollard in this year (according to Vollard).

1895

Meets Vollard this year, according to Jean Renoir. March 3: Morisot dies. Summer–Autumn: Stays in Dieppe, possibly with the Berards; visits Jacques-Emile Blanche. November: Admires the exhibition of Cézanne's latest works at Vollard's gallery. December: Buys a house in Essoyes, and falls out with Cézanne over the next month.

1896

March: Involved with Monet and Degas in the installation of the Morisot retrospective at Durand-Ruel's. July 15: Goes to Germany, to Wagner concerts in Bayreuth and to museums in Dresden. November 11: Death of his mother, aged 89, at Louveciennes.

1897

February: A proportion of the Caillebotte bequest, including Renoir's *Dance at the Moulin de la Galette* (fig. 67), is finally displayed in the Musée du Luxembourg. August: Breaks his arm for the second time by falling off his bicycle.

1898

February: Pays probably his first visit to Cagnes on the Côte d'Azur and will subsequently spend the early part of each year in the region. October: Goes to The Netherlands and sees a major Rembrandt exhibition in Amsterdam. December 12: Sells Degas's *Dance Lesson*, his gift from Caillebotte, to Durand-Ruel, precipitating a quarrel with Degas. December: Partially paralyzed in his right arm following a severe rheumatic attack.

1899

Takes regular thermal health cures in the south of France to treat his rheumatism from now on. May 1: Donates a painting to a sale organized by Monet on behalf of Sisley's children, following the painter's death on January 29. Early June: The Chocquet sale takes place.

1900

January–February: Solo exhibition of sixty-eight works at the Bernheim-Jeune gallery. Summer: Shows eleven paintings at the Exposition Universelle in Paris despite an initial refusal to lend. August 16: Is made a Chevalier de la Légion d'Honneur.

1901

August 4: Third son, Claude, is born in Essoyes. October: Rents an apartment and a separate studio on rue Caulaincourt (18th arrondissement). October–November: Exhibits twenty-three works at the Paul Cassirer Gallery in Berlin.

1902

January–late April: In Le Cannet at the Villa Printemps with Aline and sons. June: Solo exhibition at Durand-Ruel's gallery in Paris of forty works. Incorporates the neighboring house at Essoyes into his own to enlarge the property. 1902 onward: Serious deterioration of his health with increasingly severe rheumatic attacks and a partially atrophied nerve in his left eye.

1903

February–March: In Le Cannet and afterward in Cagnes, where he will rent Maison de la Poste each winter until 1907. November 13: Death of Pissarro. November–December: Has suspicions about his studio neighbor when the collector Viau is accused of having forgeries of his works.

1904

January: Pursues the matter of the forgeries with a complaint to the "Procureur de la République," but drops it on legal advice. Spends the summer in Essoyes. October–November: Given his own room at the Salon d'Automne and shows thirty-five works.

1905

January–February: Fifty-nine of his works are included in an Impressionist show at the Grafton Galleries in London by Durand-Ruel. May 8–9: The Berard sale. Summer: Builds a new studio at Essoyes. October–November: Made Honorary President of the Salon d'Automne and exhibits nine works.

1906

Spends the Winter in Cagnes and the summer in Essoyes. October–November: Shows five works at the Salon d'Automne. Cézanne dies in this year.

1907

April 11: Charpentier sale. *Madame Georges Charpentier and Her Children* (fig. 25) is bought by The Metropolitan Museum of Art in New York for 84,000 French francs. June 28: Buys an estate in Cagnes, Les Collettes, and commences building work on a house there. October: Made Honorary President of the Salon d'Automne once again, despite not exhibiting.

1908

March: Preoccupied with the planting of the garden at Les Collettes. Mid–July: To Essoyes, where he apparently sits for a portrait bust by Maillol. Autumn: Moves into the house at Les Collettes upon its completion and is visited by Monet late in the year.

1909

Spends the year in Cagnes and Essoyes. December 6–7: The second Viau sale.

1910

April–October: Has a retrospective of thirty-seven works at the ninth Venice Biennale. Travels to Germany and stays in Munich with Mme Thurneyssen, the daughter of Edouard Berard. Increasing immobility and frailty force him to give up walking upon his return. October–November: Exhibits one painting at the Salon d'Automne.

1911

Confined from now on to a wheelchair. January: Mme Cézanne and her son stay in Cagnes. October 20: Made an Officier de la Légion d'Honneur, upon which he is congratulated by Rodin. Meier-Graefe's German monograph on Renoir is published, with a French translation appearing the following year.

1912

January–March: Rheumatism prevents him from getting to the studio at Les Collettes so takes an apartment in Nice. January–February: Lends forty-one works to the Tannhauser Gallery in Munich and the Paul Cassirer Gallery in Berlin. Has twenty-one works on show at Durand-Ruel's in New York, and twenty-four at the Centennial Exhibition of French Art (1812–1912) at the French Institute in St. Petersburg. Seventy-four works are displayed at Durand-Ruel's in Paris in April–May, and fifty-eight portraits in June. After a sudden attack of paralysis, is operated on in August and convalesces at Chaville. October–November: Has two works at the Salon d'Automne.

1913

February–March: Has five works at the Armory Show in New York. Summer: In Essoyes where, at Vollard's suggestion, he takes up sculpture, with the assistance of Richard Guino, who is a pupil of Maillol. Winter 1913–14: His time is split between Les Collettes and the apartment in Nice at 1, place de l'Eglise du Voeu.

1914

February: Has thirty works at Durand-Ruel's in New York. March: Engaged on a tapestry design for the Gobelins factory. June 4: Three of his paintings are left to the Louvre by the collector Isaac de Camondo (died 1911). August 3: War is declared by Germany. October: Both Pierre and Jean Renoir are wounded and hospitalized.

1915

April: Jean Renoir is seriously wounded and hospitalized in Gérardmer. Aline goes to visit him and herself dies on her return to Nice. December: Instructs Durand-Ruel and Vollard to inventory all his works in Paris. Autumn 1915–spring 1916: In Cagnes.

1916

Summer: In Paris and Essoyes, where he asks Guino to join him and to model a bust after a study of Aline seated (fig. 45).

1917

January: Eighteen works shown at Durand-Ruel's in New York. Learns of Degas's death on September 27. Autumn:

Begins Claude's instruction in ceramics. Late December: Unhappy with the collaboration with Guino, who leaves Cagnes in January. December 31: Matisse visits in Cagnes for the first time.

1918
February–March: Twenty-eight works shown at Durand-Ruel's in New York. March: Pleased with the reproductions that illustrate Vollard's monograph on Renoir. With the German advance, deposits remaining works in Essoyes and Paris with friends for safe-keeping. Several large canvases are rolled up and brought back by Pierre Renoir to the apartment in Nice. The collector René Gimpel visits and finds Renoir in very poor health, with a foot that is possibly gangrenous.

1919
February 19: Made a Commandeur de la Légion d'Honneur. April: Exhibits thirty-five works at Durand-Ruel's in New York. May: Congratulates Albert André when his monograph is published. July: In Essoyes. August: Invited to the Louvre by Paul Léon, the Director of Fine Arts, where *Portrait of Madame Charpentier* is hanging in the La Caze room with other recent museum purchases. December 3: Following a congestion of the lungs, Renoir dies in Cagnes, and is buried three days later beside his wife at Essoyes.

LIST OF WORKS

An asterisk () indicates a work that is included in the exhibition*

* Fig. 1
Madame Henriot en travesti (Madame Henriot in Costume)
c. 1875–77
Oil on canvas
63½ × 41¼ in. (161.3 × 104.8 cm)
Columbus Museum of Art, Museum Purchase, Howald Fund

* Fig. 2
The Laundress
1877–79
Oil on canvas
32¹⁄₁₆ × 22¼ in. (81.4 × 56.5 cm)
The Art Institute of Chicago, Charles H. and Mary F.S. Worcester Collection

Fig. 3
The Parisienne
1874
Oil on canvas
63 × 41½ in. (160 × 106 cm)
National Museums and Galleries of Wales, Cardiff

Fig. 4
At the Café
c. 1877
Oil on canvas
13¾ × 11 in. (35 × 28 cm)
Kröller-Müller Museum, Otterlo

Fig. 5
At the Milliner's
c. 1878
Oil on canvas
12¾ × 9⅗ in. (32.4 × 24.5 cm)
Fogg Art Museum, Harvard University Art Museums, Cambridge MA

* Fig. 6
Young Girls (In the Street)
c. 1877
Oil on canvas
17⁵⁄₁₆ × 14⅛ in. (44 × 36.5 cm)
Ny Carlsberg Glyptotek, Copenhagen

Fig. 7
La Place Clichy
c. 1880
Oil on canvas
25½ × 21¼ in. (65 × 54 cm)
Fitzwilliam Museum, University of Cambridge, Cambridge

Fig. 8
The Umbrellas
c. 1881–85
Oil on canvas
71 × 45½ in. (180 × 115 cm)
The National Gallery, London

* Fig. 9
Gabrielle Reading
1906
Oil on canvas
21⅝ × 18⅜ in. (55 × 46.5 cm)
Staatliche Kunsthalle, Karlsruhe

* Fig. 10 *Young Woman Reading an Illustrated Journal*
c. 1880–81
Oil on canvas
18 × 22 in. (46 × 56 cm)
Museum of Art, Rhode Island School of Design, Providence, Museum Appropriation

Fig. 11
Lise (Woman with a Parasol)
1867
Oil on canvas
71½ × 44½ in. (184 × 115 cm)
Museum Folkwang, Essen

Fig. 12 Edgar Degas (1834–1917)
At the Café (Absinthe)
1875–76
Oil on canvas
36¼ × 26¾ in. (92 × 68 cm)
Musée d'Orsay, Paris

Fig. 13
Dance in the Country
1882–83
Oil on canvas
71 × 35½ in. (180 × 90 cm)
Musée d'Orsay, Paris

Fig. 14
Dance in the City
1882–83
Oil on canvas
71 × 35½ in. (180 × 90 cm)
Musée d'Orsay, Paris

Fig. 15
Workers' Daughters on the Boulevard
(Illustration for
Emile Zola's *L'Assommoir*)
1877–78
Pen and brown ink, over black chalk, on ivory laid paper
10½ × 15¾ in. (27.5 × 39.9 cm)
The Art Institute of Chicago, The Regenstein Collection

* Fig. 16
The Green Jardinière
1882
Oil on canvas
36½ × 26¾ in. (92.7 × 67.9 cm)
Toledo Museum of Art, Purchased with funds from the Edward Drummond Libbey Endowment, Gift of Edward Drummond Libbey

* Fig. 17
The Piano Lesson
c. 1889
Oil on canvas
22 × 18 in. (56 × 46 cm)
Joslyn Art Museum, Omaha, Museum Purchase

Fig. 18
Woman at the Piano
1875–76
Oil on canvas
36¾ × 29¼ in. (93.2 × 74.2 cm)
The Art Institute of Chicago, Mr. and Mrs. Martin A. Ryerson Collection

* Fig. 19
Portrait of a Girl Sewing, 1900
Oil on canvas
21¼ × 17¾ in. (54 × 45.1 cm)
Saint Louis Art Museum

* Fig. 20
Seamstress at a Window
c. 1908–10
Oil on canvas
25½ × 21½ in. (64.8 × 54.6 cm)
New Orleans Museum of Art, Gift of
Mr. Charles C. Henderson in
memory of Margaret Henderson

* Fig. 21
Portrait of Marie-Zélie Laporte
c. 1864
Oil on canvas
22 × 18⅛ in. (55.8 × 46.1 cm)
Musée municipal de l'Évêché,
Limoges

* Fig. 22
Madame Henriot
c. 1876
Oil on canvas
26 × 19⅝ in. (66 × 50 cm)
National Gallery of Art,
Washington, D.C., Gift of the
Adele R. Levy Fund, Inc.

Fig. 23
The Theater Box
1874
Oil on canvas
31½ × 25 in. (80 × 63 cm)
Courtauld Institute Gallery, London,
The Samuel Courtauld Trust

* Fig. 24
Madame Victor Chocquet
1875
Oil on canvas
29½ × 23⅝ in. (75 × 60 cm)
Staatsgalerie, Stuttgart

Fig. 25
*Madame Georges Charpentier and
Her Children*
1878
Oil on canvas
60½ × 74⅞ in. (153.7 × 190.2 cm)
The Metropolitan Museum of Art,
New York, Catharine Lorillard Wolfe
Collection

* Fig. 26
Mademoiselle Romaine Lacaux
1864
Oil on canvas
32 × 25⅝ in. (81 × 65 cm)
The Cleveland Museum of Art,
Gift of the Hanna Fund

Fig. 27
Studies of the Children of Paul Berard
1881
Oil on canvas
24½ × 32½ in. (62.6 × 82 cm)
Sterling and Francine Clark Art
Institute, Williamstown MA

* Fig. 28
Thérèse Berard
1879
Oil on canvas
22 × 18½ in. (56 × 47 cm)
Sterling and Francine Clark Art
Institute, Williamstown MA

Fig. 29
Jeanne Durand-Ruel
1876
Oil on canvas
44 × 29½ in. (113 × 74 cm)
The Barnes Foundation, Merion PA

Fig. 30
Alice and Elisabeth Cahen d'Anvers
1881
Oil on canvas
47 × 29 in. (120 × 75 cm)
Museu de Arte de São Paulo

* Fig. 31
The Hat Pin
1897
Lithograph on paper
image 23 × 19¼ in (58.4 × 48.9 cm)
The Minneapolis Institute of Arts,
Gift of Bruce B. Dayton

* Fig. 32
Two Girls Reading
1890–91
Oil on canvas
22 × 18⅝ in (55.9 × 47.2 cm)
Los Angeles County Museum of Art,
The Armand Hammer Collection

* Fig. 33
Little Girl with a Hat
1894
Oil on canvas
16¼ × 13 in. (41.2 × 33 cm)
Indianapolis Museum of Art,
Presented to the Art Association
by James E. Roberts

* Fig. 34
Young Girl with a Hat
c. 1890
Oil on canvas,
16⁵⁄₁₆ × 12½ in. (41.5 × 32.5 cm)
The Montreal Museum of Fine
Arts; Purchase, grant from the
Government of Canada under
the terms of the Cultural Property
Export and Import Act and gifts
of Mr. and Mrs. A.T. Henderson,
the families of the late M. Dorthea
Millar and the late J. Lesley Ross,
the Bank of Montreal, Redpath
Industries, Ltd., and the
Royal Trust Company, in memory
of Huntly Redpath Drummond

* Fig. 35
The Gypsy Girl
1879
Pastel on prepared canvas
23 × 14¼ in. (58.4 × 33.9 cm)
Columbus Museum of Art,
Gift of Howard D. and Babette L.
Sirak, the Donors to the
Campaign for Excellence, and
the Derby Fund

* Fig. 36
The Gypsy Girl
1879
Oil on canvas
29 × 21½ in. (73.5 × 54.5 cm)
Herbert Black Collection, Canada

* Fig. 37
The Picture Book
c. 1895
Oil on canvas
15½ × 12½ in. (39 × 32 cm)
Collection of The Dixon Gallery and
Gardens, Memphis, Museum
Purchase

Fig. 38
*Portrait of Aline Charigot,
later Madame Renoir*
1885
Oil on canvas
25¾ × 21¼ in. (65.4 × 54 cm)
Philadelphia Museum of Art,
W.P. Wilstach Collection

Fig. 39
The Luncheon of the Boating Party
1880–81
Oil on canvas
51¼ × 69⅛ in. (130 × 173 cm)
The Phillips Collection,
Washington, D.C.

Fig. 40
Motherhood
1885
Oil on canvas
35¾ × 28½ in. (91 × 72 cm)
Musée d'Orsay, Paris

Fig. 41
*Mother and Child (Aline and
Pierre/Washerwoman and Baby)*
c. 1886
Pastel
32 × 25¾ in. (79 × 63.5 cm)
The Cleveland Museum of Art,
jointly owned by the Museum
and an anonymous collector

* Fig. 42
The Lesson
1906
Oil on canvas
25½ × 33½ in. (65 × 85 cm)
Private collection, London,
via Galerie Daniel Malingue, Paris

* Fig. 43
Mother and Child
c. 1912
Lithograph
19½ × 18⅞ in. (49.5 × 47.9 cm)
Memorial Art Gallery of the
University of Rochester, New York,
Marion Stratton Gould Fund

* Fig. 44
Maternity: Madame Renoir and Son
c. 1916
Terracotta
20⅛ × 9¾ × 12¾ in.
(51.1 × 24.8 × 32.4 cm)
National Gallery of Art,
Washington, D.C., Collection of
Mr. and Mrs. Paul Mellon

* Fig. 45
Mother and Child
1916
Bronze
height 21 3/16 in. (53.8 cm)
The Baltimore Museum of Art,
The Cone Collection, formed by
Dr. Claribel Cone and Miss Etta Cone
of Baltimore MD

Fig. 46
*Madame Clémentine Valensin Stora in
Algerian Dress*
1870
Oil on canvas
33¼ × 23½ in. (84.5 × 59.6 cm)
Fine Arts Museums of San Francisco,
Gift of Mr. and Mrs. Prentis Cobb
Hale in honor of Thomas Carr
Howe, Jr.

Fig. 47
Odalisque
1870
Oil on canvas
27¼ × 48¼ in. (69.2 × 122.6 cm)
National Gallery of Art,
Washington, D.C.,
Chester Dale Collection

* Fig. 48
Reclining Odalisque
1919
Oil on canvas
13⅜ × 22 1/16 in. (34 × 56 cm)
Ny Carlsberg Glyptotek, Copenhagen

Fig. 49
*Mademoiselle Fleury in Algerian
Costume*
1882
Oil on canvas
49¾ × 30¾ in. (126.5 × 78.2 cm)
Francine and Sterling Clark Art
Institute, Williamstown MA

* Fig. 50
Dancing Girl with Tambourine
1909
Oil on canvas
61 × 25½ in. (155 × 64.8 cm)
The National Gallery, London

* Fig. 51
Dancing Girl with Castanets
1909
Oil on canvas
61 × 25½ in. (155 × 64.8 cm)
The National Gallery, London

* Fig. 52
The Concert
1918–19
Oil on canvas
29¾ × 36½ in. (75.6 × 92.7 cm)
Art Gallery of Ontario, Toronto, Gift
of Rubens Wells Leonard Estate

* Fig. 53
Woman with a Mandolin
1919
Oil on canvas
22 × 22 in. (56 × 56 cm)
Collection of Rita K. Hillman

Fig. 54
Diana
1867
Oil on canvas
77 × 51¼ in. (199.5 × 129.5 cm)
National Gallery of Art,
Washington, D.C., Chester Dale
Collection

Fig. 55
Nude in the Sunlight
1875–76
Oil on canvas
31½ × 25¼ in. (81 × 65 cm)
Musée d'Orsay, Paris

* Fig. 56
Small Blue Nude
1878–79
Oil on canvas
17 9/16 × 15 1/16 in. (46.4 × 38.2 cm)
Albright-Knox Art Gallery, Buffalo

Fig. 57
The Braid
1887
Oil on canvas
22½ × 18½ in. (57 × 47 cm)
Museum Langmatt Stiftung
Langmatt, Baden, Sidney and
Jenny Brown

Fig. 58
Edgar Degas (1834–1917)
*Nude Woman Drying Her Foot
after the Bath*
1885–86
Pastel
21¼ × 20½ in. (54 × 52 cm)
Musée d'Orsay, Paris

Fig. 59
The Great Bathers
1884–87
Oil on canvas
46⅜ × 67¼ in. (117.8 × 170.8 cm)
Philadelphia Museum of Art,
The Mr. and Mrs. Carroll S.
Tyson, Jr. Collection

* Fig. 60
Seated Bather
1903–06
Oil on canvas
45¾ × 35 in. (116.2 × 88.9 cm)
The Detroit Institute of Arts, Bequest
of Robert H. Tannahill

* Fig. 61
Bather
1912
Oil on canvas
25¾ × 22 in. (65.4 × 55.9 cm)
Toledo Museum of Art, Purchased
with funds given by Mrs. C. Lockhart
McKelvy

Fig. 62
The Bathers
c. 1918–19
Oil on canvas
43³⁄₁₆ × 63 in. (110 × 160 cm)
Musée d'Orsay, Paris

* Fig. 63
Bathing Woman
c. 1903–06
Oil on canvas
23⅝ × 21¼ in. (60 × 54 cm)
National Museum of Art, Architecture
and Design, Oslo

Fig. 64
Venus Victorious
1914
Bronze
23¾ × 12¼ × 7¾ in. (60.3 × 31 × 19.7 cm)
Hirshhorn Museum and Sculpture
Garden, Washington, D.C.,
Gift of Joseph H. Hirshhorn

* Fig. 65
Christine Lerolle Embroidering
c. 1895–98
Oil on canvas
32⅛ × 25⅞ in. (82.5 × 65.8 cm)
The Columbus Museum of Art, Gift
of Howard D. and Babette L. Sirak,
the Donors to the Campaign for
Excellence, and the Derby Fund

Fig. 66
Breakfast at Berneval
1898
Oil on canvas
32 × 26 in. (82 × 66 cm)
Private collection

Fig. 67
Dance at the Moulin de la Galette
1876
Oil on canvas
51½ × 69 in. (131 × 175 cm)
Musée d'Orsay, Paris

Fig. 68
Edgar Degas (1834–1917)
*Self-Portrait with Christine and
Yvonne Lerolle*
1895–96
Gelatin silver print, 8 × 10 in.
(20.3 × 25.4 cm)
Musée d'Orsay, Paris

Fig. 69
Christine Lerolle (detail)
1897
Oil on canvas
26½ × 21 in. (57.5 × 53.5 cm)
Private collection

Fig. 70
*Yvonne and Christine Lerolle at the
Piano*
c. 1897
Oil on canvas
29 × 36 in. (73 × 92 cm)
Musée de l'Orangerie, Paris

Fig. 71
Portrait of Henry Lerolle
c. 1895–97
Oil on canvas
18⅛ × 13¾ in. (46 × 35 cm)
Private Collection

Fig. 72
Jan Vermeer (1632–1675)
The Lacemaker
c. 1669–70
Oil on canvas laid down on wood
9½ × 12¼ in. (24 × 31 cm)
Musée du Louvre, Paris

* Fig. 73
Claude and Renée
1903
Oil on canvas
31 × 25 in. (78.7 × 63.5 cm)
National Gallery of Canada, Ottawa

Fig. 74
Marie-Thérèse Durand-Ruel Sewing
1882
Oil on canvas
25½ × 21³⁄₁₆ in. (64.8 × 53.8 cm)
Sterling and Francine Clark Art
Institute, Williamstown MA

Fig. 75
Claude Monet (1840–1926)
Madame Monet Embroidering
1875
Oil on canvas
25⅝ × 21⅝ in. (65 × 55 cm)
The Barnes Foundation,
Merion PA

Fig. 76
Odilon Redon (1840–1916)
*Madame Arthur Fontaine
(Marie Escudier)*
1901
Pastel on paper
28½ × 22½ in. (72.4 × 57.2 cm)
The Metropolitan Museum of Art,
New York, The Mr. and Mrs. Henry
Ittleson Jr. Purchase Fund

Fig. 77
The Embroiderers
1902
Oil on canvas
39¾ × 32⅛ in. (101 × 81.6 cm)
The Barnes Foundation, Merion PA

Fig. 78
Self-Portrait
c. 1875
Oil on canvas
15⅜ × 12½ in. (39.1 × 31.7 cm)
Sterling and Francine Clark Art
Institute, Williamstown MA

Fig. 79
Portrait of Pierre-Auguste Renoir
1875
Musée d'Orsay, Paris

FURTHER READING

Albert André, *Renoir*, Paris (G. Cress) 1928

Patrick Bade, *Renoir*, London (Studio Editions) 1990

Roger Benjamin, *Renoir and Algeria*, New Haven CT and
London (Yale University Press) 2003

Anthea Callen, *Renoir*, London (Oresko Books) 1978

François Daulte, *Pierre-Auguste Renoir, Watercolours, Pastels
and Drawings in Colour*, London (Faber and Faber) 1959

François Daulte, *Auguste Renoir, Catalogue raisonné de
l'oeuvre peint*, I, *Figures 1860–1890*, Lausanne (Editions
Durand-Ruel) 1971

Douglas W. Druick, *Renoir: the Artist in Focus*, Chicago
(The Art Institute of Chicago) 1997

Julius Meier-Graefe, *Renoir*, Leipzig (Klinkhardt and
Biermann) 1929

Berthe Morisot, *Correspondance de Berthe Morisot*, Paris
(Quatre Chemins Editart) 1950

Linda Nochlin, *Bathtime: Renoir, Cézanne, Daumier and the
Practices of Bathing in Nineteenth-Century France*,
Groningen (Gerson Lectures Foundation) 1991

Camille Pissarro, *Correspondance de Camille Pissarro
1865–1885*, I, ed. Janine Bailly Herzberg, Paris (Presses
Universitaires de France) 1980

Renoir, exhib. cat., essays by John House, Anne Distel,
Lawrence Gowing, London, Paris and Boston 1985–86,
New York (Abrams) 1985

Renoir: Master Impressionist, exhib. cat., ed. John House,
Sydney, Queensland Art Gallery (Art Exhibitions
Australia) 1994

Jean Renoir, *Renoir*, Paris (Hachette) 1962

Jean Renoir, *Renoir, My Father*, transl. Randolph and
Dorothy Weaver [1958], 1962; London (Collins) 1962

Renoir's Portraits: Impressions of an Age, exhib. cat., ed. Colin
Bailey, Anne Distel, Linda Nochlin, Ottawa, Chicago,
and Fort Worth 1997–98, New Haven CT and London
(Yale University Press) 1997

John Rewald, *The History of Impressionism*, 4th rev. edn, New
York (The Museum of Modern Art) 1973

Georges Rivière, *Renoir et ses amis*, Paris (H. Floury) 1921

Lionello Venturi, *Les Archives de l'Impressionnisme. Lettres de
Renoir, Monet, Pissarro, Sisley et autres. Mémoires de Paul
Durand-Ruel*. Documents, I, II, Paris and New York
(Editions Durand-Ruel) 1939

Ambroise Vollard, *La Vie et l'œuvre de Pierre-Auguste Renoir*,
Paris (A. Vollard) 1919

Ambroise Vollard, *Renoir: An Intimate Record*, transl. Harold
L. van Doren and Randolph T. Weaver [1925],
republished New York (Dover Publications) 1990

Barbara Ehrlich White, *An Analysis of Renoir's Development
from 1877 to 1887*, Ann Arbor MI (University Microfilms)
1965

Barbara Ehrlich White, *Renoir: His Life, Art and Letters*, New
York (Abrams) 1984

Barbara Ehrlich White, "Renoir's Sensuous Women" in
Woman as Sex Object, ed. T. Hess and L. Nochlin, London
(Allen Lane) 1973

LENDERS TO THE EXHIBITION

Albright-Knox Art Gallery, Buffalo

Art Gallery of Ontario, Toronto

The Art Institute of Chicago

The Baltimore Museum of Art

Herbert Black

The Cleveland Museum of Art

Columbus Museum of Art

The Detroit Institute of Arts

The Dixon Gallery and Gardens, Memphis

Rita K. Hillman

Indianapolis Museum of Art

Joslyn Art Museum, Omaha

Los Angeles County Museum of Art

Memorial Art Gallery, The University of Rochester

The Minneapolis Institute of Arts

The Montreal Museum of Fine Arts

Musée municipal de l'Evêché, Limoges

The National Gallery, London

National Gallery of Art, Washington, D.C.

National Gallery of Canada, Ottawa

National Museum of Art, Architecture and Design, Oslo

New Orleans Museum of Art

Ny Carlsberg Glyptotek, Copenhagen

Private collector, London

Rhode Island School of Design, Museum of Art, Providence

Saint Louis Art Museum

Staatliche Kunsthalle, Karlsruhe

Staatsgalerie, Stuttgart

Sterling and Francine Clark Art Institute, Williamstown

Toledo Museum of Art

PICTURE CREDITS

INDEX

Fig. 79 Portrait of Pierre-Auguste Renoir, 1875

Musée d'Orsay, Paris